How to Draw from Photographs

Diane Cardaci

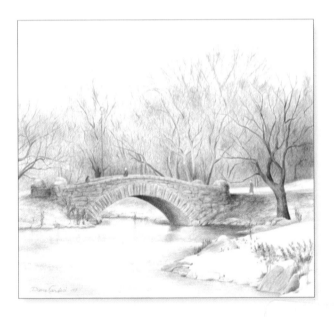

www.walterfoster.com
Walter Foster Publishing, Inc.
3 Wrigley, Suite A
Irvine, CA 92618

Project Editor: Jenna Winterberg • Designer: Shelley Baugh • Production Artist: Debbie Aiken

1 3 5 7 9 10 8 6 4 2

Contents

Introduction

When artists view the world, they see inspiration at every turn—from an arrangement of fruit at the market to the way the rain is glistening off cars in the rain. But with the hectic pace of modern life, it's not always possible to come to a screeching halt in order to depict whatever inspiration you've encountered. Keeping a camera at your side is the next best thing—it captures the moment for you, pausing the action and recording all the visual details for your use at a more convenient time, when you too have time to stop.

We are very lucky to live in an age where taking photographs is so easy. From inexpensive pocket-sized digital cameras to the more costly professional single-lens reflex (SLR) cameras, there is a device to suit every artist. Digital cameras allow us to take a large quantity of photos without regard to the cost of film or processing. And with the advancement of automated point-and-shoot technology, one need not even fear the technical side of photography! Today, the artist who does not take advantage of this amazing tool in pursuing his/her individual vision is rare indeed.

Photographs can be a great asset to the artist—but as wonderful a tool as the camera is, it is important for us to remember that too much reliance on the photograph can interfere with the artistic process.

In spite of the ease of use of many cameras, it is still important to learn some basic skills to properly capture an artistic subject—and also to interpret that subject before taking it from the photo to the page. In this book, I'll show you some of the many ways that photographs can be an asset to the artist, as well as helping you avoid some common pitfalls. So let's take a look at how this very modern tool can help with a timeless art!

Tools and Materials

You can create almost any texture imaginable with a pencil and paper. You won't need a lot of supplies to follow the exercises in this book, but it's important to get acquainted with the basics. As you work, you can experiment with different tools to discover which ones suit you best.

Pencils

Pencils are labeled with numbers and letters. The letter indicates hard lead (H) or soft lead (B), and the number describes the grade—the higher the number, the more intense the hardness or softness of the lead. So a 9B is the softest of the B leads; a 2B is mildly soft. HB is in between hard and soft. Soft leads create thicker, darker lines; hard leads produce thinner, lighter lines.

There are several types of pencils: Wood-less pencils feature larger leads that can form fine points; mechanical pencils create uniform strokes; carpenter's pencils create very wide strokes; water-soluble pencils produce washes that are similar to watercolor paint when manipulated with water; and lead holders are "sleeves" that can hold any grade of lead.

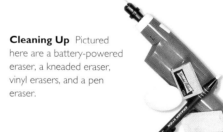

Choosing Your Pencil Pictured from left to right are a carpenter's pencil, a woodless graphite pencil, and large and small lead holders.

Erasers

Erasers are great for creating highlights and for shading. I prefer kneaded erasers because they can be molded into different shapes and sizes to suit my needs. They're softer and more flexible than vinyl erasers, the type you usually see in schools. They are great for cleaning up a finished drawing because they don't leave crumbs.

Cleaning Up Pictured here are a battery-powered eraser, a kneaded eraser, vinyl erasers, and a pen eraser.

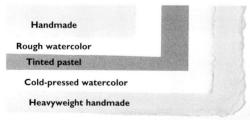

Handmade

Rough watercolor

Tinted pastel

Cold-pressed watercolor

Heavyweight handmade

Experimenting with Papers There is a great variety of papers you can choose from. Pictured from top to bottom are a small handmade paper, which has a deckle edge and is ideal for smaller drawings; a rough watercolor paper, which has a very rugged, but regular, pattern; a tinted pastel paper, which has a nice tooth; a cold-pressed watercolor paper, which is great for laying washes with water-soluble pencil; and finally a heavyweight handmade paper, which has a very rough, irregular tooth.

Papers

Your choice of paper is as important as your choice of pencil. I mainly use Bristol board, a heavy paper available in vellum (rough) or plate (smooth) finish. Rough, *cold-pressed* papers create a deeper tone and break up the stroke, which is great for drawing stone and landscape textures. Smooth, *hot-pressed* papers provide the ideal surface for delicacy and detail. The rougher the surface, the more "tooth" (or texture) the paper has. Use acid-free papers whenever possible to avoid yellowing and deterioration.

Sharpeners

Carpenter's pencils and other specialty pencils can be sharpened manually with a single-edge blade and/or a sandpaper block. Mechanical pencils have special sharpeners for the leads, called "pointers." For my wood pencils, I usually use an electric sharpener. Most artists use a combination of all these sharpeners, depending on the type of point they want. A mechanical sharpener will give you a very fine point, but you have little control over it. Sandpaper can make some nice blunt points that are difficult to create with other types of sharpeners. Some artists even use a utility knife to whittle their pencils into hard, sharp shapes.

Blending Tools

There are several tools that can be used to smudge and blend graphite. A *blending stump* is a rolled piece of paper that can be used for blending so you don't get your fingers dirty. A *tortillon* is similar, but shaped differently. When you're working with a larger area, you can use a chamois cloth for blending. These are important to have on hand for creating certain textures.

Supporting Your Art

A sturdy drawing surface is invaluable. Portable drawing boards are very convenient and can be used at most tables. I currently do most of my fine art at an easel because it enables me to look at the piece from a distance to see how the work is progressing. I also use a large drawing table when I need more space.

Setting Up a "Studio" For many years, my "studio" was a drawing board leaned against my kitchen table. Your workspace doesn't need to be fancy, but there are essentials, such as a comfortable chair, supplies within reach (I keep mine in a taboret), and plenty of natural light—plus artificial lights for gray days and evenings!

Sharpening Your Tools Each type of pencil has a specific sharpener. If you're using a carpenter's pencil, you can find a blade and sandpaper at the hardware store. When you're done sharpening, the shavings can be used as graphite powder, also called "carbon dust."

Blending Tools Made of tightly wrapped paper, tortillons are pointed on one end (right), whereas blending stumps are pointed on both ends (left).

Accessories

Rulers and triangles are indispensable for highly realistic buildings and other hard-edged subjects. Artist's drafting tape is a necessity for keeping your art in position, but do not tape within the drawing area, as this can leave residue.

Eraser Shields and Stencils Another great tool is the eraser shield (above), which acts as a stencil when erasing parts of your drawing. You also can use a ruler to help you create perfect corners and angles.

Camera Equipment

I use my camera to capture data and take photos for artistic reference, not to create frame-ready photographs. That's an important distinction, because the features I'm looking for in a camera are different than those a professional photographer would desire. For the artist, the goal is to capture information for later art use; for the photographer, the picture is the art.

Digital Revolution

I went digital years ago, and I think the same is true for most artists. These cameras are both convenient and cost-effective. Digital cameras, like film cameras, come in two basic models: the point-and-shoot and the more professional DSLR.

Point-and-shoot versions are generally less expensive. They come in a range of sizes, some small enough to fit in your pocket. They also vary in resolution, which is measured in megapixels and refers to the quality of the picture taken—a higher resolution means higher quality. These cameras have improved so much in quality in recent years that even the less expensive ones will do an adequate job for our purposes.

The drawback to point-and-shoot cameras is that they are automatic—great for sake of simplicity, but bad in that there is limited ability to change settings. There are times I definitely prefer to have more control. That control comes in the form of an SLR with a professional-quality lens. I also don't mind the extra heft of this version when I'm working in the studio, as opposed to hiking or walking outdoors.

Compact Camera My point-and-shoot weighs only about 11 ounces, making it ideal for travel. It's a 10 mexapixel, enough resolution for sharp photos from a distance. And it has a built-in zoom lens. The model I use also allows for advanced settings, such as exposure bracketing.

Digital SLR This bulkier camera is used more by professionals, but amateurs can get the hang of the basics. It's heavier, but the combination of pro lenses and 12 megapixel resolution allows me to focus on features and capture detail. It's perfect for indoor portraiture.

Camera Accessories

Digital cameras require a small investment in memory cards and batteries. SLR cameras require the same—plus at least one lens to operate. Here's a quick look at the accessories you'll need.

Film and Memory
Digital cameras don't have film; they come with working memory to record data. You'll also need a memory card compatible with your model. The greater the capacity, the more high-resolution photos you can take at one time without having to switch cards, download to your computer, or delete.

Lens and Flash
Some SLR cameras are sold with one basic lens—but the camera is inoperable without this addition. Flashes are also sold separately. Both accessories can be expensive. Start with one lens and one flash—and then expand later if needed.

Taking the Photo

Once you've purchased your camera, it's important to understand some photography fundamentals before shooting your reference photos—even if the camera you decided on is a point-and-shoot.

ISO Settings

ISO refers to how sensitive film is to light. With digital cameras, it refers to the sensitivity of the camera's image sensors. Point-and-shoot cameras have an automated ISO: The camera will lower the ISO in bright light and increase it in dim light. Both my cameras allow me to adjust the ISO setting, affording me more control. I always use the lowest ISO possible, because as the number goes up, the picture quality goes down.

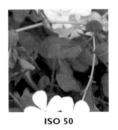 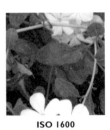

ISO 50 **ISO 1600**

In the first photo, the lower ISO results in a sharper photo. In the second, the higher ISO has a grainy result. In certain low-light situations, you'll need a higher ISO regardless of clarity loss—the fuzzy result will work for reference.

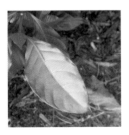

Foreground Focus
When I focus my camera on these leaves, the venation of the main leaf is very sharp, and the highlights and shadows are clearly defined. But the background is very blurry.

Background Focus I switch my focus to the background. This won't be the central focus of the drawing, but it's an important detail I may need later. Here the sticks and the dirt are very clear.

Focus

Point-and-shoot cameras auto-focus, but they do so based on where you're pointing the camera, so you can still take multiple shots of a subject, focusing in on different parts to capture every detail. On the SLR, auto-focus is sometimes an option, but adjusting the lens gives you more control.

Auto Exposure When I let the camera decide the "correct" exposure, the detail of the clouds and snow-capped mountain are evident, but the foreground and trees are too dark.

Higher Exposure I manually increased the exposure to capture a lighter foreground and trees, and now I can see much more detail. The sky, however, is washed out.

Exposure Bracketing

More advanced point-and-shoot cameras will allow you to manipulate the exposure—how much light the camera lets in when you press the shutter release. Too much light can overexpose a photo, leaving it "blown out." Too little light can underexpose an image, making it appear dark. I frequently take three shots of the same subject to make sure I have one with the right exposure when I get back to the studio.

Lower Exposure With this setting, I managed crisper clouds and snow-capped mountain. But the foreground and middle ground are way too dark to make out details.

Fixing Distortion

Have you ever looked at a photo or yourself and thought, "That's not my nose!" or "Why do my eyes look so funny?" It isn't just your ego protesting the unflattering image—photos can lie! Distorted images are a fact of photography. The camera records the subject according to the focal length of the lens. And adjusting that focal length can produce very different results. Thankfully, you can correct distortion in your drawing.

Lenses and Distance Lens focal lengths vary from wide (less than 35mm, for landscapes) and mid-range (85–120mm, for portraiture) to telephoto (greater than 135mm, for sport or nature). Here the lens is correct, but I stood too close and pointed upward. For portraits, use an appropriate focal length and hold the camera at nose level to minimize distortion.

Using Your Zoom Here I stepped back as far as I could, using my zoom to get "closer," decreasing distortion. As an exercise, shoot the same subject with different focal lengths and from different distances. Remember: A wide-angle lens makes distances between foreground and background appear bigger, whereas a telephoto lens compresses the distance.

Correcting Distortion

Even if you've managed to minimize distortion in a photo, you may wish to correct for the remaining bit before using the image as a reference for a drawing. I'll show you how.

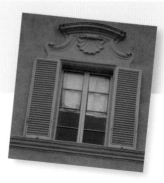

Photo The distortion in this photo is slight—although we'll correct for it, that won't prevent us from using the original for details..

Step One Start with a basic outline. I make two horizontal lines to establish the band at the bottom of the window before adding the verticals. I refer to my reference to determine the correct proportion for the top horizontal. And then I add guides for the pediment.

Step Two I draw two more verticals to represent the outside edges of the shutters, and then I make three horizontal lines to represent the windowpanes. After adding several more horizontal guidelines, I draw a simple outline of the pediment.

Step Three With the structure established, I tape a piece of tracing vellum over the construction drawing. Now I draw the window again, using the guideline underneath, and this time I add details, such as the shutter slats, and pediment.

Understanding Lighting

Making a subject appear three-dimensional on a two-dimensional surface is the challenge every pencil artist faces. Working for a photo of a properly lit subject makes that challenge less daunting, as the correct lighting can bring out the best in the subject, enhancing the form with a proper balance of light and shadow.

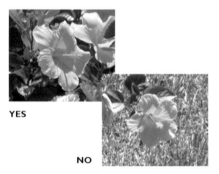

YES

NO

Look for Defining Shadows

These flowers are on the same bush—but the cast shadows make them very different subjects. On the first, the center is in a curving shadow, which brings out the depth and shape of the form. The lighting creates a gently curving cast shadow over the petal, which helps define the form of the stamen and pistil as well the petal itself. But in the second photo, the shadows are scattered and haphazard; they confuse rather than define the shape.

Avoid Unnatural Cast Shadows

Introducing interesting shapes in cast shadows may seem like a good idea from an artistic perspective, but often they just confuse the viewer. Initially, I placed this melon under a chair so that the shadows from the mesh pattern of the seat would fall on the melon. But the shadow destroyed the sense of form. When I took away the seat, the natural form shadow was no longer confused by the cast shadow of the chair.

NO YES

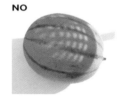
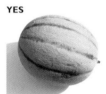

Avoid Flat Lighting

These photos depict the same Cypress tree, under two distinct lighting conditions. In the first, it was a cloudy day. The result? Flat lighting on both the tree and bush. In the second, the sun was shining— and it was early, so the light was at an angle rather than shining from straight above. The result was an ideal lighting situation to highlight the form of the bush and produce interesting but subtle shadows.

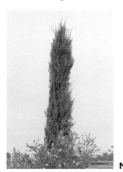
NO

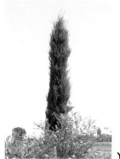
YES

Artist's Tip

When I find myself with a photo that I want to use but the lighting is not good, I use several techniques to help visualize better lighting:

1. I draw the basic shape of the object, such as a long cylinder for a tall tree, and then shade it as it were in sunlight.

2. I sculpt a simplified form in clay. Then I place the "sculpture" under a spotlight to study the lighting.

3. I seek out additional reference photos—particularly helpful for animals, who don't understand holding a pose!

Approaching the Drawing

Once you select a photograph to work from, you can begin your drawing. Rather than get overwhelmed by all the information in the photo, I start with the basics, working toward more detail gradually. I recommend that you look for large, basic shapes in your photo—for example, the overall round shape of a tree's leaves. As you're studying those shapes, take note of the proportions—is the tree trunk shape more square or rectangular? How much taller is it than it is wide? It's helpful to notice angles, too. For example, is a tree trunk leaning? Getting this basic information transferred to the page will provide a solid framework for your more-developed drawing.

Artist's Tip

Some people prefer to copy over lines and shapes from a photo using a grid as a guide. See page 24 for more details.

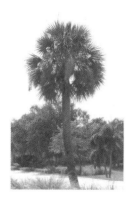

Angular Palm For this palm, I first establish the angle of the tree trunk's base with a straight line. Then I draw a second line coming from where the trunk begins to straighten. After determining the width of the trunk and marking the lines to match, I make a large circle to represent the full set of fronds, making it proportional to the trunk. Now I have a good foundation to work from.

Leaning Palm Even when you're drawing the "same" subject (here, another similar palm), the shape can be quite different. Draw what you see, not what you expect to see. With this palm, the trunk is leaning more—and in the opposite direction of the first tree. The point where the tree begins to straighten out is much closer to the top of this trunk, which is also taller and thinner. And here, I need to draw a line to establish the angle of the fronds in addition to the circle that encompasses the shape.

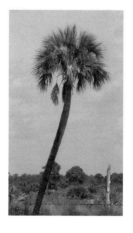

Vertical Palm Here's yet another palm tree—with yet another different set of shapes, proportions, and angles. In this example, the trunk is almost completely vertical. The fronds fill out a shape similar to a triangle, but I choose to add extra lines to better establish the fronds, representing the true form rather than trying to make the fronds fit a recognizable geometric shape. As with the earlier drawings, the particular proportions and angles of the subject are as important as the shapes themselves.

Composition Basics

The way the elements are arranged on the page—or the composition—is important, because it allows you to lead the viewer's eye around the page, ultimately directing it toward the focal point. You should keep these composition basics in mind when taking your photos—but there will still be many situations where you'll want to alter the composition of a photo reference or combine more than one reference, meaning you'll often be composing on the page instead of through the lens.

Common Composition Schemes

Oval The eye travels around the picture in an oval path. Each time the eye begins to move toward the side of the picture, an element located there (such as a tree branch) redirects it back inside.

S-shape The eye zigzags throughout the picture, as if following a winding road. The path should not begin or end in the corner of the picture, so that the viewer's eye is not drawn out of the picture.

L-shape Here, a large vertical shape along the side and a horizontal shape along the bottom take up the better part of the composition. For example, there could be a large expanse of sky framed by a tree to the left and ground at the base.

Steelyard In this example, a small shape in the background balances out a larger one in the foreground—such as a barn directing the eye toward a country house. The two elements can't be too like in size, lest they fight for attention.

Rule of Thirds

In a drawing, there should always be a *focal point*, or center of interest. The Rule of Thirds is one very simple guide for the placement of that focal point. To follow the rule of thirds, divide your drawing into three equal parts horizontally and then vertically. The lines cross at four points—use any one as a guide for placement of your focal point.

The Rule of Thirds is not the only guide for placing the focal point, but it's frequently used by artists, and very reliable.

Drawing Techniques

There are many, many ways to use your pencil to create lines and textures. Here, I've demonstrated some more common techniques. Practice these and develop your own, too! Don't be afraid to switch between the point and side of the pencil for different effects. Experiment with the pressure as well as the length of the strokes. And try varying the width between strokes to create lighter or darker tones.

Cross-hatching Draw even parallel strokes, and then change the direction and repeat. You can even change angles several times, creating darker tone.

Curved Cross-hatching Make parallel strokes as with regular cross-hatching, but this time curving them. These are useful to describe the curves on a rounded form.

Parallel Strokes Long horizontal strokes are an option for light shading. These can be also be curved, wavy, or zigzag. Long, slightly wavy strokes are great for water.

Stippling Create dots with your pencil, using either a sharp or a dull point. Varying the size of the pencil lead or the size of the dots will change the appearance.

Blending with a Stump Dip the stump into graphite powder and smear it on the paper. This is a fast way to lay down tone, also producing the effect of a wash.

Lifting Out Take an eraser to a toned area of paper to remove graphite. A vinyl eraser will create sharp lines, whereas a kneaded eraser will produce softer shapes.

Curving Strokes Group short, slightly curving strokes together to reproduce a very natural-looking texture, which can be useful for trees and bushes as well as animal fur.

U-Shaped Strokes Grouping many U-shaped lines together results in a sharper, more defined texture, such as what you might use for pebbles or rocks on the ground.

Scribbling Use random, loose scribbles for light shading of rounded forms, or tighter ones like these to create textures for leaves, dirt, or even rocks.

Developing Style

Just because we're creating a realistic drawing from a photo reference doesn't mean we want our drawing to be identical to the source. After all, part of being an artist is imbuing each of your pieces with your personal style! One of the best ways to develop your style and become comfortable with adding your own personal touches is to get in the habit of daily sketching. Start making quick studies, taking fifteen minutes or so out of your day to develop your skills and your eye.

Quick Sketch Studies

Tree on a Hill When I sketch like this, I like to use a large lead so I don't focus on details. After establishing the shapes with a 2B, I switch to the side of a 6B large lead for tone, pressing harder for shadows and using short up-and-down stroke on the hill.

Cypress Trees Limit the time you spend on each subject so that you're forced to focus on the main masses and not the details. Establish the basic shapes and angles, and then quickly indicate texture and tone.

Field with Trees I also find the stump helpful for quick toning. Here, I use a stump with some graphite on it to smear tone over the tree shapes in a circular motion. I also lightly touch tone on the hill before going over the trees with the side of a large-lead 6B.

Transferring the Drawing

Because I like to work from basic shapes, slowly defining the elements of my sketch, I typically work out my composition sketch on a sheet of extra drawing paper, then transferring the final outline to a nicer piece of art board to finish. Transferring the sketch is simple once you understand the basics of the process.

Step One Use a 6B pencil to completely cover the back side of your sketch paper, the side opposite the image. For an even layer of coverage, you may wish to use a facial tissue or stump to smear the graphite.

Step Two Next turn the sketch right-side up, and lay the graphite side down on top of the art board you've selected for your final drawing. (Tape it in place if you like.) Lightly retrace the lines of your sketch with a sharp pencil.

Step Three Check the art board underneath occasionally to be sure you're not pressing too hard. (Too much pressure could leave permanent indentations on your surface.) When you've retraced all the lines, your transfer is complete!

Staging a Composition

A favorite pet napping in the sun or wild flowers swaying in the breeze make great subjects for drawings, but not all potential subjects will come composition-ready. For example, I'm often inspired by hand-painted pottery. But photographing a beautiful piece where I discover it on a cluttered shelf that's covered in dust certainly won't do it any justice! Setting up your own still life composition puts you in control, allowing you to stage the subject in the best light—figuratively and literally! Not only can you adjust lighting, you also can physically move various objects within the composition to achieve a picture-perfect reference, as I've done in this still life example.

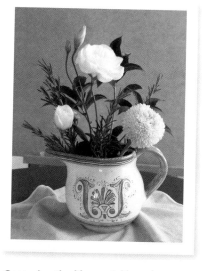

Capturing the Moment Near a large window, I play with the elements to find the best arrangement, lighting, and pattern of shadows. Many artists would then begin drawing, but I begin photographing. Still lifes are inanimate, but natural lighting shifts quickly, transforming highlights and shadows. Photography stops time—a real advantage!

Step One First establish the main shapes. I block in simple outlines with an HB, starting with the largest shape, the circular pitcher bowl. I relate the size and position of the flowers to the "vase," studying the photo for proportion clues; for example, the two largest blossoms are the same width, about half the width of the pitcher.

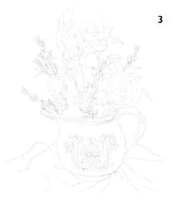

3

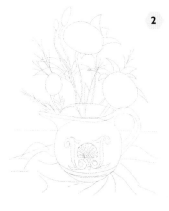

Step Two With the main shapes established, it's time to rough in smaller detail shapes. Still using the HB, I map out the design on the pitcher, and then I draw rounded triangles for leaves, varying the lengths according to the proportions I see in my photo. I establish some of the main branches of Rosemary, adding short lines to represent needles. I also map out a few cloth fold lines.

Step Three After securing heavyweight tracing vellum over my sketch with artist's drafting tape, I sharpen my HB for a more refined outline, using the basic sketch as guide. I delineate the petals of the Lisianthus blossoms and make short curving lines for the Chrysanthemum texture. I also refine the leaves and Rosemary. I detail the pitcher, but decide not to copy the table line. I transfer this drawing to plate-finish Bristol paper.

14

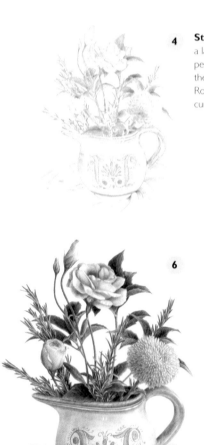

Step Four I refer to the photo to find the main shadow patterns. Then, with a large blending stump, I apply the lightest tone to the shadows of the Lisianthus petals before laying a slightly darker tone on the shadows of the mum. For the leaves, I deepen the tone, switching to the stump's point for stems and Rosemary needles. Using the stump's side, I shade the pitcher using horizontal curved strokes that follow the form. I also add basic shading to the cloth.

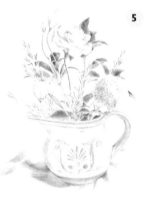

Step Five With my HB, I make long strokes in the direction of the petals' curves. For leaves, needles, and stems, I switch to a 2B, applying heavier pressure for deeper shadows. Next I switch to the tip of the stump to revisit the leaves, adding tone to deepen the value. I indicate lighter shadows on the mum. Then, returning to my HB, I shade the pitcher and cloth with long curved strokes.

Step Six I deepen tones starting with the leaves, where I apply a 4B with heavy pressure, blend with a stump, and repeat. I alternate between a 2B and a 4B for stems and needles, and then use an HB on the flowers, with small U-shaped strokes for the mum's texture. I use a 2B for the Lisianthus' deepest and the mum's larger shadows. I also tone the pitcher with the sides of the 2B and HB before picking out highlights with a kneaded eraser. Next I tone the decoration with the 4B, and the cloth using the side of the 2B. After a final check against my photo, I clean up with my eraser.

Playing with Lighting

Lighting can be soft and diffuse or bright and intense. And depending on the position of the light source, it can create strong silhouettes or shape-defining highlights. The possibilities are endless! Don't be afraid to play and experiment—the more you do, the more interesting results you'll produce. You might be surprised by what you discover!

NO The slightly elevated viewpoint from which we're viewing provides a roundness to the bottom and lip of the vase. But the backlighting of the subject means this rounded form has no highlights; it becomes a silhouette with a somewhat flat and two-dimensional look. Backlighting can be great for creating drama, but when the form is more important than the mood, it may not be the right choice.

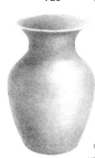

YES In this example, we're again viewing the vase from slightly above. But something has changed: This time, the vase appears more three-dimensional. The difference is in the lighting. With the light source directed toward the vase from a 3/4 angle, a nice highlight and form shadow result, further defining the roundness and dimension of the form. By emphasizing its form, we've put this vase in the best light!

Contrasting Values for Effect

Manipulating shapes and lighting aren't the only ways to breathe life into a still life composition. Incorporating a balanced range of values and creating strong contrasts among them will draw immediate attention to your work. You may have noticed that I took a little artistic license and deepened the tones of the flowers in the project on pages 14–15 for greater variety and a stronger statement—but this lesson goes even farther, selecting objects of varying tones that make a striking appearance when grouped together.

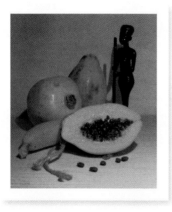

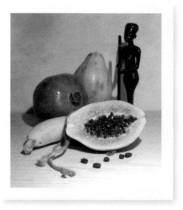

Choosing a Theme When I saw my neighbor's hand-carved figurine from Kenya, I knew it had to become the centerpiece of this still life. Sticking to a geographical theme, I chose fruits and items related to that region. Variety was key—for the most interest, I was keen on including different sizes, shapes, and textures as well as values.

Making Adjustments After I set up the light source set to best define the forms, I took photos at three different exposures to capture all the details. But exposure isn't the only difference between this photo and the one at left. After taking my initial photos, I examined the values and realized I needed a darker pomegranate for contrast!

Step One I begin my blocking with the largest shapes. Because the figurine is a complicated object, I opt for a slightly angled rectangle so that I can focus on the space the figure occupies and its proportion in relation to the other objects without getting mired in details. Likewise, I don't allow myself to get distracted by the many seeds of the papaya, depicting their mass shape instead.

Step Two Now my focus switches to better defining the outlines. For the figurine, think of her head as an oval and the cane as a long rectangle. I indicate the location of the facial features with a few short lines. Looking at the *negative shapes* (the space surrounding the object) helps me draw the figure more accurately. I also look at the negative space around the papaya seeds to better define the mass.

Step Three I'm going to use the outlines I've established to guide a more refined sketch now, so I tape a piece of heavyweight transparent vellum over my drawing and redraw the composition, this time with more detail on the rope and seeds inside the papaya. I refine the hairline on the figure and map out the features of her face, as well as adding details to her fingers. When I have a solid sketch, I transfer to a piece of Bristol paper.

3

4

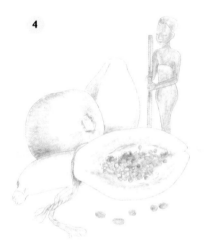

Step Four Referring to my value study, I start smearing in tone with a large blending stump and graphite powder. First I cover the figure, using small circular strokes on the dress portion for texture. For the fruits (except the seeds), I follow the forms, making long curved strokes with the stump's side and adding darker tones in shadows for a little basic modeling. For the rope, I apply quick, irregular strokes, working darker tone in where the cut papaya casts a shadow. I use a darker tone for the seeds, creating a type of graphite wash layer over the lines of the seeds. And I use the point of the stump to tone the coffee beans.

Value Study

Before I begin shading, it's important to have a strategy. This quick thumbnail maps out the major values of the composition using flat tones. Sketching a value study will help you look at your design from a different perspective, focusing on shades instead of just shapes. (Making this study is what made me realize I needed a darker pomegranate!) The thumbnail also will help you as you draw, reminding you to pay attention to the "colors" and not get so caught up only in the form of the objects.

Creating a Value Scale

When thinking of an object's value, "light" or "dark" isn't as helpful as "lighter than" or "darker than." In fact, *value* is defined as the "relative" lightness or darkness of a color of black. In nature, values have infinite *gradations*, or degrees. The forms we see are a result of this variation. A value scale reduces the vast scale into values we can see.

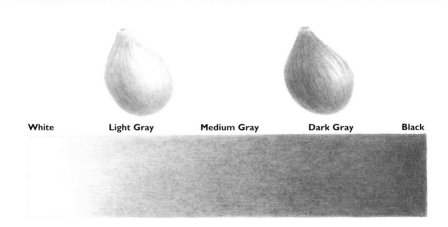

| White | Light Gray | Medium Gray | Dark Gray | Black |

This scale shows the transition from white through gray to black. Although subjects have a *core value*, the central color or tone, they also contain many other values in their highlights and lowlights; that variation is what helps us see the form. Here I've placed two figs on the value scale for comparison. The "white" fig (really a light green) has a medium core value, but its lightest highlights are white and its darkest form shadows are medium–dark gray. In the case of the "black" fig (actually a deep purple), the core value is dark, therefore it has more dark shading than the white fig—but even this dark fig has a white highlight! Understanding the value variations in your subject will help you depict them more accurately.

5

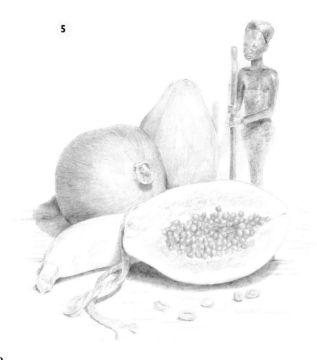

Step Five Using the side of a 4B, I add deep shadows to the figure, also applying small circular strokes to the hair and dress before picking out highlights with a kneaded eraser. With the side of a 2B, I draw the figure's cast shadow and tone the fruit, varying pressure. I deepen the pomegranate's value before developing its shadows with a 4B, which I also use to create more cast shadows. For the rope, I make spiral-shaped lines with the point of an HB, varying pressure. I add texture to the cut papaya with light pressure and uneven strokes applied with the side of a large 6B—the dull point of which I use with heavy pressure to shade the seeds.

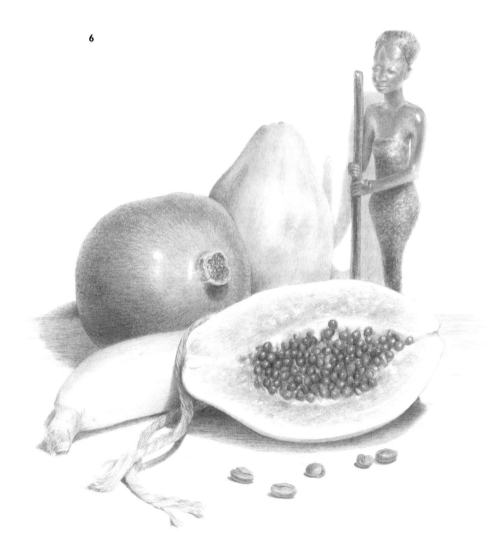

Step Six To refine the figurine, deepen the wall shadow, and build up the fruit. I work with a 2B, a 4B, and a stump, pulling highlights with a kneaded eraser. For detailed areas, I use the point of an HB. For the dress, I use scallop strokes, switching to circles for the hair. I pick up the large 6B to stipple on the pomegranate, to shade the rope, and to deepen cast shadows. I apply spiral strokes to the rope with the point of the HB. With eraser in hand to lighten areas, I use the point of a 4B to refine the seeds and coffee, and the side of a 2B to add texture to the fruit. To finish, I create the table's wood grain using a sharp HB.

Showcasing Light Subjects

Light and white objects puzzle many artists, but they can be a real joy to work with once you figure out the right approach. First it's important to establish that no "white" subject is ever truly white; light shading depicts the gray-toned lights and highlights of even white subjects, which would have no form or dimension without. Even with this gray shading, we can create the illusion of a white object by employing the contrast of a dark background, which simultaneously directs the eye to the lighter object and creates interest. A dark background further helps us define the shape of the object; when we fill in the negative space, the shape of the lighter object appears. I'll show you how it's done with a pretty white ibis!

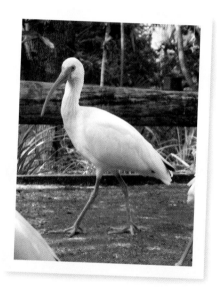

▶ **Tracking Down a Subject** The ibis is a frequent visitor to my backyard. Unfortunately, I never seem to get my camera out before it moves on to visit another neighbor. So I decided to go to the local zoo—often in zoos and parks, birds and animals are more comfortable with people, making them easier to photograph. The ibis spends a lot of time near water and is very active, so I knew I wanted to show these features in my drawing. With that in mind, I followed the birds around with my camera, squatting at their eye level. And I got a great shot!

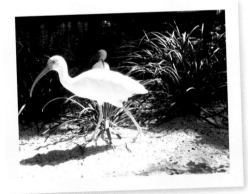

◀ **Combining References** While at the zoo, I took pictures with water and grasses in the background too. None of those ibis shots would've made a good drawing, but that doesn't mean I need to abandon them all together. Instead, I combine references, pairing the best ibis pose with this photo, which has a pleasing background with dark tones that will emphasize the bird's whiteness. Remember that you don't have to use everything in your references.

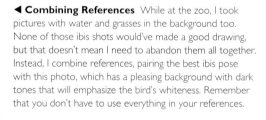

Step One Approaching a light subject is the same as drawing any other at the start. When I look at my reference, I see that the body is an elongated egg shape. For the neck, the curve is important, as is making sure the length and width are proportionate to the body. For the head and beak, I check proportions and angles against the photo. I sketch simple lines to represent legs and feet, and I place the eye and pattern on the head. Then I turn to a second photo for the background, adding a few lines for the ground and some of the main curves for the grasses.

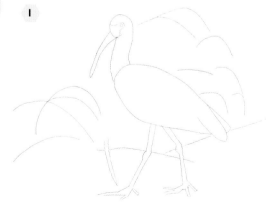

2

Step Two Because I'm combining references, my rough sketch is the first time I'm seeing my subject and background together in one design. Mapping out the basic shapes helps me determine if I've made a good choice, which I think I have. Now I can move on to sketching in a few more details, such as feathers, the line where the feathers meet the leg, and the beak opening. I also draw a few more grass blades, adding a second line to each to get a better feel for the dimension

Step Three Now it's time to use my guide to create a more refined sketch. After taping a piece of heavyweight vellum over my initial drawing, I redraw the bird, this time eliminating unnecessary construction lines and creating a more natural shape. I add in a few short lines to indicate texture amongst the feathers, using elongated U-shaped lines to delineate larger feathers. Next I redraw the grasses, mixing in additional blades of grass. And I draw a few lines on the ground to indicate a texture there.

3

4

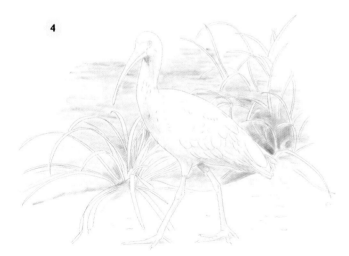

Step Four After transferring my sketch to a piece of plate Bristol, I take a large stump, dip it in graphite powder, and use the side to lay tone for the water, making long horizontal strokes. I create variation with a second layer in places before switching to the stump's point to darken between grass blades and add light ground shadows. With the side of a thinner stump, I apply very light shading to the bird. With the point of a very thin stump, I darken the eye and add a shadow under the feet.

Defining Dark Subjects

Just as I use the dark of the negative space to help define light subjects, I use light spaces to help shape and define dark subjects when I'm drawing them. Whether it's dark water in the background or a blackbird's head in the foreground, dark subject matter finds me "drawing" a lot with my eraser! First I establish a dark base tone, and then I lift out to create the lighter tones and highlights.

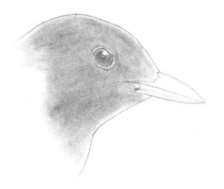

Step 1 After establishing the outline, I shade the head with a medium stump, stroking in the direction of the feathers. Before moving on to the eye, I determine the location of the highlight so I can "save" the white of the paper. Working around that area, I darken the eye and pupil with the stump. Then, with a very light touch, I add tone to the lower beak.

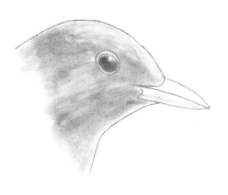

Step 2 After the initial tone is placed, I use the eraser as I would a pencil, making strokes that follow the direction of the feather texture. As I lift out tone, the form of the bird's head becomes more developed. A kneaded eraser is ideal for this task, because it can be molded into different shapes, producing a nice variation in line thickness.

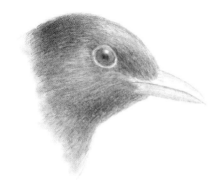

Step 3 Now I alternate between pencils and my eraser to refine the development. I use both the side and point of a 2B to create short strokes for the feather texture. Then I develop the darkest areas with a 4B. I shade the beak using an HB and a 2B. And then I revisit the highlights, lifting out the tone with a kneaded eraser to create variation in the head and eye.

5

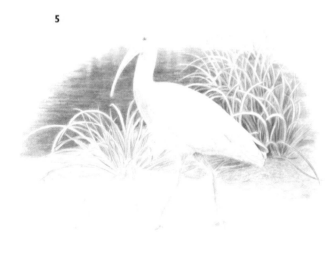

Step Five Developing the background will make it easier to determine the appropriate values for the "white" subject in contrast. So with the side of a 2B and then a 4B, I apply horizontal strokes to the water, varying pressure and spacing, and lifting out reflections. As I work, I also lift out the grass blades to keep the edges clean. I return to the side of the 2B to shade the grass with long strokes. Using the side of a 6B lead in a large holder, I add texture to the ground with extremely light pressure, letting the paper pick up irregular touches of graphite. With the point of an HB, I add texture to the bird with short strokes, lightly shade the beak with long strokes, and delineate the eye. Then I fill in the dark pupil with a sharp 2B.

6

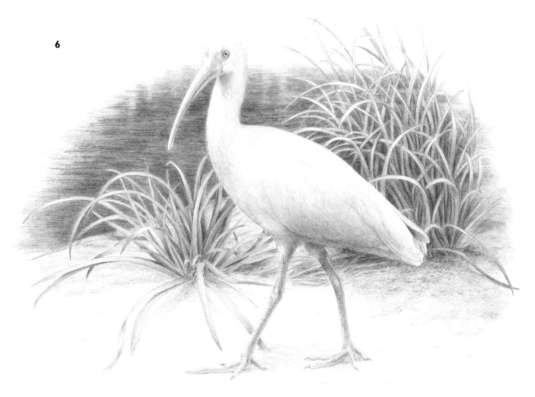

Step Six I refine the grass blades with the side and point of a 2B. Where necessary, I darken the spaces between the blades using the 2B and a 4B. With the side of the 4B, I add texture to the ground. The negative space surrounding the ibis is well developed, defining the bird's shape; now it's time to refine the form. With the side of 2B, I model the beak, using the point for the edges. For feathers, I alternate between the sides and points of an HB and a 2B. The feather texture of the ibis is subtle, so I work with a light touch and slowly build up tone, using my kneaded eraser to pick out light areas. Around the neck, I apply short strokes, switching to longer strokes for the body and larger feathers. I use heavier pressure only in the shadowed areas on the bird's underside. For the legs, I make long strokes with the side of the 2B; over these, I apply shorter curved strokes across the legs with the point of the pencil. I also use the point of the pencil to draw the details of the feet. When satisfied, I use the kneaded eraser to pick out the last of the highlights.

Using a Grid as a Guide

Portraits, whether of people or of pets, pose a special challenge. No one is going to notice if you draw a raccoon and its eyes are a bit closer together than the original's, but if you change the shape of Sparky's nose . . . The grid method is a useful technique for drawing exactly what you see, getting all the proportions and details precisely correct. With this approach, you simply draw a grid on your photo and the same size grid (or a proportionately larger or smaller one) on your drawing paper. The grid breaks up your subject into smaller, more manageable parts while providing a guide for placement and sizing. I'll show you how it works using a friendly Labrador Retriever.

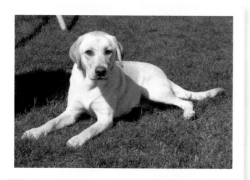

Photographing a Pet I like to take pet photos outdoors in the sun. I set my camera to three-exposure bracketing and follow the animal, coming down to eye level and taking shots from different angles. I usually take 200 to 300 shots, as pets don't understand posing! Then I choose an image that showcases the animal's personality, form-defining shadows, and a nice design. In this case, I liked the angle of her face, the position of her body, and the angle of her tail.

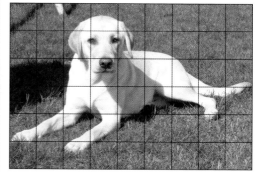

Establishing the Grid You can draw a grid directly on your photo (using a ruler to make even squares), or you can digitally superimpose one. I like to keep my photo clean for reference, so I simply print a grid out on acetate and attach it above my photo with drafting tape. I print the same grid on a regular piece of paper for my sketch (as I'll be refining the drawing on a separate piece of art paper, anyway).

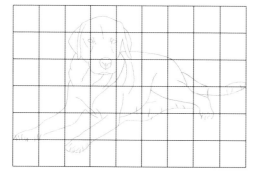

Transferring by Grid With my grids in place, I can switch my focus to the main outline. Instead of sketching in the general outlines of the shapes as I usually do, I now look at each square individually, drawing the outline of the shape within the corresponding square on the copy paper. It doesn't matter where you start on the page with this method! Once I have drawn each square, I go back and check for accuracy, square by square.

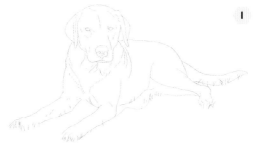

Step One The grid method is ideal for accurate line drawings; when my base outline is complete, though, I tape a piece of heavyweight tracing paper over the line drawing to create a carefully refined sketch. I touch in additional lines to indicate fur at this stage, particularly where it indicates underlying muscle. I also draw in lines of grass. When I finish, I transfer the drawing to smooth Bristol paper, cleaning up the with a sharp HB and a kneaded eraser.

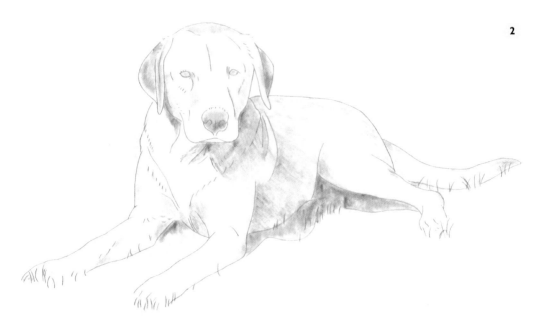

Step Two I study the direction of hair growth in the photo before applying a graphite wash base. Using a large stump covered with graphite powder, I stroke in the direction of the hair growth to establish shadows and the dog's darker coloration. For the head and ears, as well as for the body, legs, and tail, I apply short strokes with the stump tip. I also use the tip to add a dark base value to the eyes and nose. For the head's cast shadow, I apply long strokes with the stump's side. I then make irregular strokes for a deep tone on the shadowed grass.

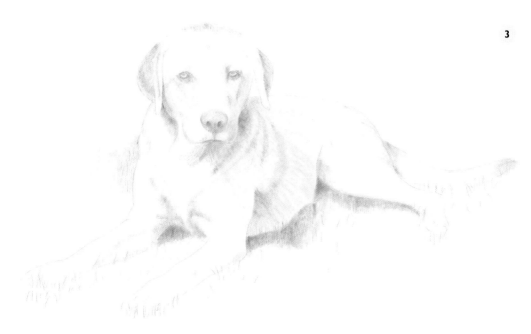

Step Three I pick up a 2B to draw over the base wash, making quick, short strokes that are a bit varied around the head and ears as well as the body and legs, and curving them where the hair curves around the body. I add some hair to the tail before applying short strokes around the eyes, establishing texture. Then I use the pencil point to better define the eye, also indicating the pupil. Using the side of the pencil, I darken the nose with small circular strokes. Finally, I add texture to the grass, alternating between curved and straight strokes.

Understanding the Subject

Remember those 200 photos I took before beginning this drawing? Well, I didn't just discard the ones that weren't perfectly suited for portraiture. Those additional photos come in handy as references. Before I start drawing, I like to have a clear understanding of the animal's form, and viewing the pet from different angles helps me do so. Varied viewpoints also assist me in making determinations about patterns of hair growth—you might see something from one angle that you missed from another. Going through my photos—and even making some rough sketches of what I see, as in the cat example below—helps ensure that I'm correctly interpreting the animal's shape and form in the final drawing.

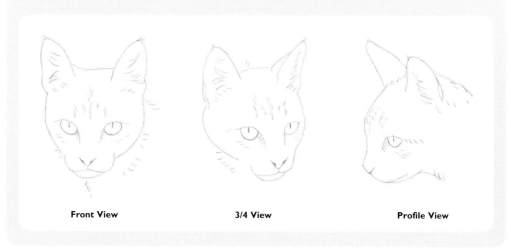

Front View **3/4 View** **Profile View**

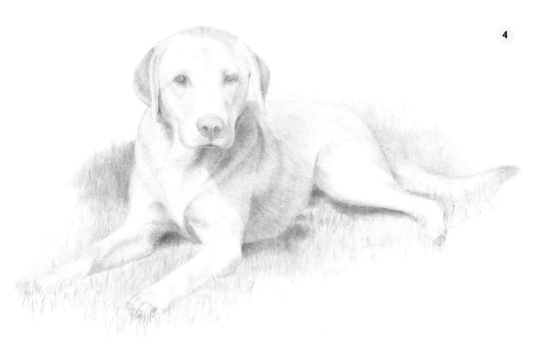

Step Four I continue building up hair texture using the tip of a 2B and heavier pressure, reminding myself to vary the strokes so they don't become too mechanical and regular. I use the side of the pencil to add shading, following the direction of the form. I further define both the nose and the eye before using my kneaded eraser to pick out highlights. I then use the side of a 4B to deepen tones in the grass, applying very heavy pressure in the shadow areas. I use the points of the 2B and 4B to add more grass texture, again with varying strokes.

Step Five Now using the sharp point of an HB, I better define the eye, nose, and mouth; create more texture on the head; and develop the ears' cast shadows. For the ears themselves, I use both a 2B and a 4B. I also deepen values below the nose with the 4B. With the point of an HB, I develop detail on the paws and create texture in the lightest areas of hair. For the grass, I use my kneaded eraser to pick out lighter blades and patches, switching to a stump to smudge in darker areas, and then alternating between pencil and eraser again to build up texture. As the grass recedes, I use the side of the pencil to create softer texture instead of drawing blades. Then I use the eraser to pick out a few more highlights on the dog to finish.

Highlighting the Eye

Highlights on the iris and pupil are essential to creating a realistic eye, adding both life and sparkle. Sometimes it's simply a matter of replicating the highlights you see in your photo reference—but even if your photo does not include this element, your drawing should! You may need to search for other photos (of the same animal or another animal of the same species) so you can accurately depict the eye's reflective quality. No matter the animal, the process is the same for developing the highlights, as I'll demonstrate with a cat's eye here.

 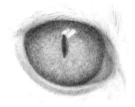

Step 1 After carefully drawing the outline of the eye shape, I block in the pupil—and the highlights, as well. Then I apply graphite with the side of a stump, smudging in a base layer of tone.

Step 2 I switch to a 2B for shading, applying radiating strokes around the pupil, working around the highlight, and making circular strokes along the iris' edge and around the eye. I apply very heavy pressure to darken the pupil.

Step 3 For the deepest shading, I use a 4B, layering small circular strokes to create the illusion of flecks of color in the iris. I use an HB to define the eye's outer edges. I use my eraser to lift out more flecks and clean up the highlights.

Working from Nature

The best inspiration often comes from nature, and I'm particularly drawn to my garden in full bloom! I often make quick sketches outdoors, but when I want to complete a more finished drawing, my camera is a great aid, as it captures the detail of the delicate subject as well as that moment's exact lighting. And sometimes the camera really rewards by capturing a fleeting moment in nature, such as the time a passing butterfly decided to pose for me on one of the prettiest flowers in my garden—the Fountain Butterfly Bush!

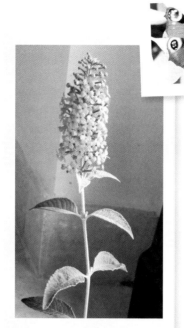

Adapting as Needed Because nature is uncontrollable, a willingness to adapt goes a long way when working with outdoor subjects! When the butterfly posed in my garden, I got a beautiful shot of the insect—but not of the flower. I continued taking photos anyway, knowing I could combine the two elements on paper. But then the sun didn't cooperate, and I couldn't get a good pattern of light and shadow. So I adapted again, this time bringing the outdoors indoors and photographing a flower from my garden in the natural light from my window.

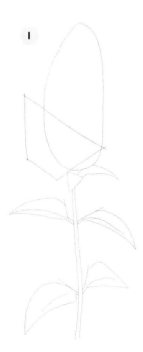

Step One Don't be intimidated by intricate subjects like this Fountain Butterfly Bush. The small details can wait; at this stage, simply look for large shapes. After positioning an elongated oval for the blossom mass, I block in the butterfly, referring to my photos to be sure the proportion is correct in relation to the flower. I pay careful attention to the angles and the shape of the negative space as I sketch the leaves.

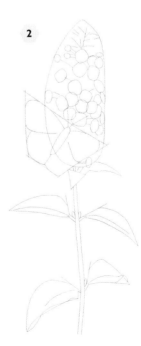

Step Two Now I move on to smaller shapes, but still keep my sketch very vague, looking to establish placement and proportion before focusing on details. I draw small circles in the oval to represent the placement of the florets, also adding lines to indicate those that have not opened. Moving on to the butterfly, I demarcate the wings within the block, and I represent the body with a thin oval. I also create detail lines along the leaves' edges.

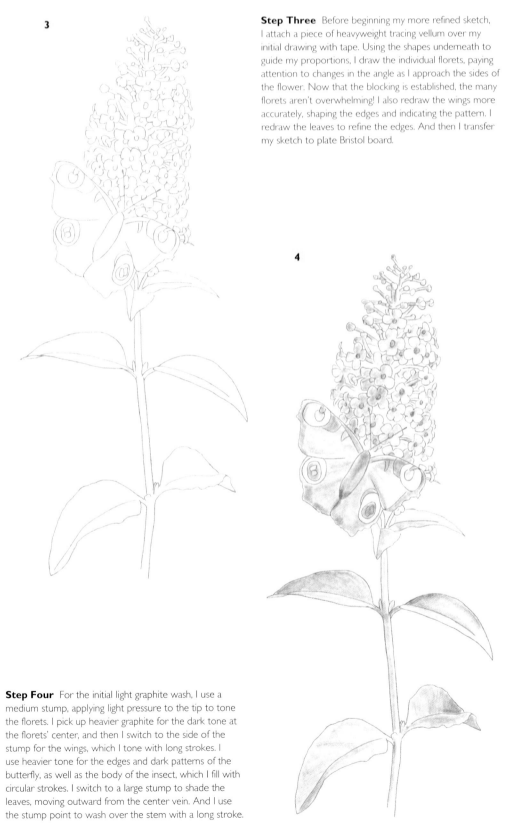

3

Step Three Before beginning my more refined sketch, I attach a piece of heavyweight tracing vellum over my initial drawing with tape. Using the shapes underneath to guide my proportions, I draw the individual florets, paying attention to changes in the angle as I approach the sides of the flower. Now that the blocking is established, the many florets aren't overwhelming! I also redraw the wings more accurately, shaping the edges and indicating the pattern. I redraw the leaves to refine the edges. And then I transfer my sketch to plate Bristol board.

4

Step Four For the initial light graphite wash, I use a medium stump, applying light pressure to the tip to tone the florets. I pick up heavier graphite for the dark tone at the florets' center, and then I switch to the side of the stump for the wings, which I tone with long strokes. I use heavier tone for the edges and dark patterns of the butterfly, as well as the body of the insect, which I fill with circular strokes. I switch to a large stump to shade the leaves, moving outward from the center vein. And I use the stump point to wash over the stem with a long stroke.

29

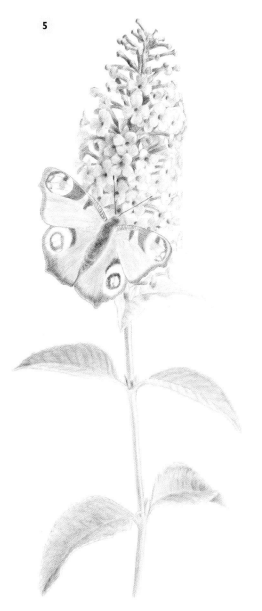

Comparing Light Intensity

On page 15, I explained why the direction of the light source was important, but I only touched upon the intensity of light—or whether it's bright and direct or soft and diffuse. Typically, I enjoy the effect of direct sunlight, as it can really make a subject more pronounced by creating strong shadows and contrasts. For this lesson, however, I was able to get better contrasts indoors with indirect lighting. It's good to always explore your options to find out what works best for each new subject!

Indirect Lighting
When lighting is soft and diffuse, there are no strong highlights on the subject. There also are no strong shadows. This can result in a subject without much variation in tone, as shown here. But indirect lighting also can produce a light and romantic feel when applied to a proper subject, such as one that already contains strong contrasts.

Step Five Using the side of a 2B, I apply somewhat heavy pressure to the upper unopened blossoms and stems. I darken the centers of the florets with the pencil point, replicating the tiny shadows, not just making dots. Now applying light pressure, I make long strokes along the wings; with a dull point, I create short strokes to add tone to the edges and make the zigzag pattern near the head. I switch to the side of a 4B for the dark portions of the wing pattern. And with circular strokes, I darken the butterfly's body. To develop the leaves, I use the side of the 2B, stroking in the direction of the veins. I also darken the stem.

Direct Lighting In this example, the intensity of the light creates stronger highlights—and stronger shadows, as well. Those contrasts and variations make the cup shape of the tulip stand out, also giving the inner petals greater definition. Strong highlights and shadows are appropriate to this bud.

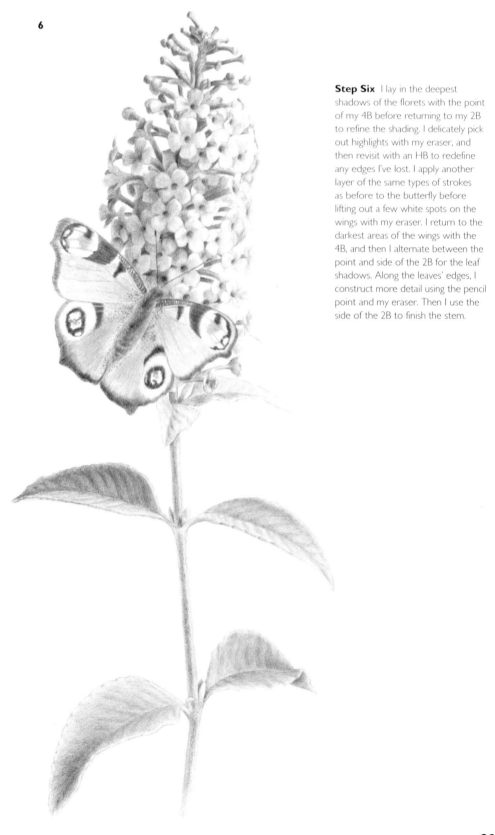

Step Six I lay in the deepest shadows of the florets with the point of my 4B before returning to my 2B to refine the shading. I delicately pick out highlights with my eraser, and then revisit with an HB to redefine any edges I've lost. I apply another layer of the same types of strokes as before to the butterfly before lifting out a few white spots on the wings with my eraser. I return to the darkest areas of the wings with the 4B, and then I alternate between the point and side of the 2B for the leaf shadows. Along the leaves' edges, I construct more detail using the pencil point and my eraser. Then I use the side of the 2B to finish the stem.

Creating a Softer Feel

Photo-realistic drawings often have a very hard, precise look to them. For some subjects, like sleek sports cars or glass vases, this is a desired effect. But for other subjects, such as forests of trees or an animal portrait, a softer feel is more appropriate. I've been softening edges in the lessons leading up to this one, but here I'm going to show you specifically how to soften edges to create a romantic vignette-style frame to create a mood and properly enhance a natural subject like this contented goat.

Using Your Imagination I was glad to have my camera when I serendipitously came across a group of relaxed goats that seemed to enjoy my attention! I quickly spotted this youth. He makes a great subject, but the hard ground and textured hay of the farm seemed a bit harsh to me. So when I remembered another not-as-eager-to-pose goat I'd seen while hiking in the Alps, I decided to root through my photos for a new background. A tree-filled backdrop will provide a pleasant setting for this sweet-faced subject while also introducing variation and interest.

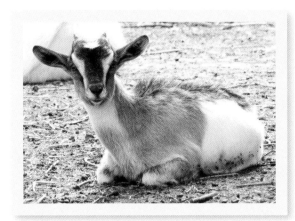

Step One As usual, I start with the largest shapes of the goat, focusing on size and placement. I draw a large oval for the body, paying attention to the proportions of the height and width. I then make two smaller ovals for the front legs that are tucked under. After studying the angle, length, and width of the neck, I draw it, and then represent the head with an egg shape. After placing the ears, I draw a line to indicate the position of the eyes. I also draw a lines for landscape elements that will direct the eye to the goat.

Step Two Next I place the facial features, using two almond shapes for eyes and a circle for the nose. Two small triangular shapes represent the horns. I sketch a few lines to indicate the dark fur patterns, and then I delineate the cup shape of the ears. I draw in a rock in the foreground (again placed to direct the viewer's eye toward the center of interest, the goat) and also add some vertical lines to establish the location of bushes in the background.

3

Step Three With the blocking complete, I attach a piece of heavyweight tracing vellum for my more refined sketch. As I draw the head, I allow the sketch underneath to guide the placement of features, but I add more detail, including the pupil, a more accurately defined dark fur pattern, and a carefully drawn nose and mouth. I add variation to the outline of the body and legs, breaking up the outline with indications of fur. I flesh out the environmental elements with vertical lines for branches, lines to represent grass, and foreground rocks. At this stage, I transfer my refined sketch to a Bristol paper.

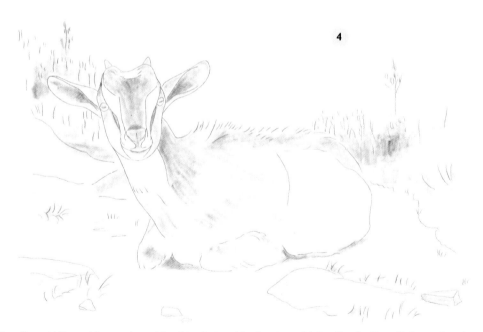

4

Step Four With graphite powder and the side of a large blending stump, I follow the direction of hair growth and loosely tone the neck and body, working around the white hair on the back. With a medium stump, I use shorter strokes to apply darker tone to the head. With the stump's point, I tone the darkest parts of the fur and inside of the ears. I return to the large stump for the loose background tone, as well as for the vertical strokes of the bushes and grass. For the ground and rock, I indicate shadows with very light pressure.

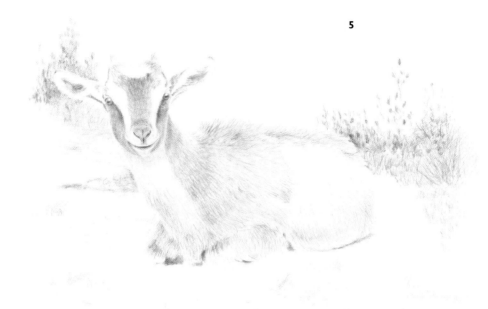

Step Five With the 2B's side, I make short strokes on the head following the hair growth. For texture, I use the point; for darker areas, I apply more pressure. With a sharp point, I draw the nose and eyes. Moving on to the neck and body, my strokes become longer and more varied. For the large bushes, I dab in smudges with the large stump, and then use the 4B side to layer in short curved strokes. For grass and shrubs, I apply short lines, long lines, and scribbles. Using the side of a large lead 6B and a light touch, I tone shadows on the ground. And I use the 2B to shade the rocks and draw grass.

Softening Edges

I love to draw "realistically," but one of the most wonderful thing about drawings is that they don't look exactly like a photograph; the artist's interpretations and subtle changes make drawings an artwork of their own. In addition to artistic liberties (such as changing backgrounds or softening shadows), one way to distinguish your drawing from a photographic reference is by softening the hard photo edges; this gives subjects a more removed feel, adding fantasy to the realism. Artists employ three main techniques to soften the overall picture: losing edges, using similar values, and rounding out edges.

Step 1 I start my drawing in the same way as usual, establishing my basic shapes and roughing in some of the larger details. Then, after I've refined the hard outline of the head, I lay in my first wash of light tone using a stump and applying graphite in circular strokes.

Step 2 After working tone into the background, I "lose" hard edges. Using my eraser, I lighten the outline where the comb receives more light, and I smudge background tone into the wattle and over the upper beak, blurring the lines of distinction and bringing the values closer. I also layer tone on flesh areas.

Step 3 After I establish the feather texture, I shade the beak, rounding the edge so there's no hard outline. As I stroke more tone over both the back of the wattle and background, I bring the values closer together. I allow part of the hard outlines defining the wattle and comb to become almost indistinct (losing edges technique). Then I finish my interpretation by developing the tone and texture of the flesh.

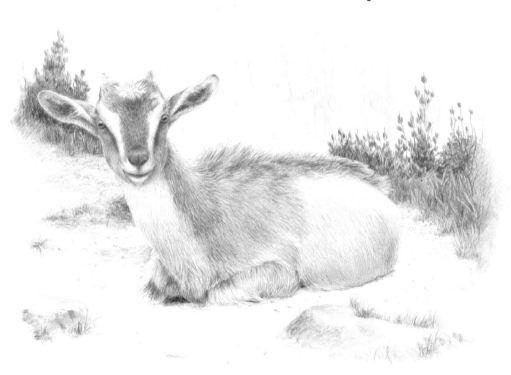

Step Six As I refine at this stage, I also focus on softening: I round edges, lose hard outlines, and blend to create similar values where edges meet. I also vignette the edges of the background, blurring so there is no clear border. I complete work on the head (see below) and then alternate between a 2B and a 4B to finish the body's texture. I use these same pencils for grass, varying pressure and direction of the strokes. For darker texture in the bushes, I make curving strokes with the dull point of a 6B. With heavier pressure and the 6B's side, I add texture to the ground before completing the shading on the rocks with a 2B. Then, after drawing my distant peak (see below), I pick out final light spots and highlights.

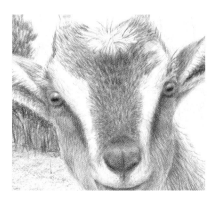

Head Detail To finish the head, I stroke in the direction of hair growth, developing texture with the dull point of a 4B and switching to the sharp point of a 2B for variation, simulating more natural texture. In the white fur, I apply light tone with the point of an HB. For the final definition of the nose and eyes, I use a 2B.

Mountain Detail To create the texture of the distant background mountain, I use the side of an HB pencil. I apply very long strokes, slightly changing the angles to create variation in the mountain rock textures. I also use the point of the pencil to create the effect of fissures in the mountain rock.

Tricking the Eye

All the drawings we've accomplished thus far in the book have been realistic depictions, but we're going to approach this project with a different method, something called "trompe l'oeil" (French for "fooling the eye"). This technique is more typically applied to painted murals, but no matter the medium, it's a way for artists to heighten the illusion of three dimensions through optical tricks, including the use of shallow depth, overlapping objects, and careful placement of shadows.

Testing the Composition

When you're dealing with multiple objects that have varying shapes, the best composition doesn't always jump out at you right away. I will rearrange the objects to find the most pleasing pattern, making small thumbnail sketches to help me simplify the composition and see the objects in a different way.

No	**No**	**Yes**

In life, I liked this selection, but when I created the thumbnail, I saw the way the horseshoe was "wedged" into the triangular space, which didn't work for me.

Horseshoe aside, here's another setup that appeared balanced at first. But when I sketched my thumbnail,, I found there was too much "weight" to one side.

I was pretty sure this composition was what I wanted. Sketching the thumbnail confirmed my suspicion. I like this balance of objects and how the shapes direct the eye.

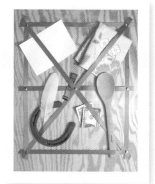

Exploring a Motif For this drawing, I decided to create a "portrait' of my family with a collection of mementos. The letter rack is a common motif within the trompe l'oeil genre, and it provided an opportunity to create a composition with layered meaning as well as visual interest. The overlapping of objects is important here, as is the shallow depth. And I adjusted the lighting to create obvious shadows, enhancing the sense of illusion.

Step One After selecting the best composition, I begin my drawing with an HB. I start with the ribbons of the letter rack, which create a gridlike pattern that will make it easier for me to place the other objects. I sketch the outlines of each shape, ignoring all detail but paying attention to accuracy for position and overlaps.

Step Two On a piece of heavyweight vellum layered over my drawing, I carefully retrace the ribbons, this time also drawing in the tacks that hold them in place. I work out the design for the surfing postcard and add the flower design detail to the folded fabric. I also add detail to the dollar bill and other objects. After carefully studying the cast shadows of each object, I outline those, as well. Then I add the grain pattern of the wood background.

2

3

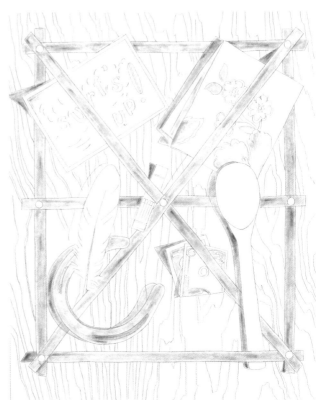

Step Three After transfering the drawing to a clean sheet of Bristol paper, I make long strokes with a large stump to add graphite tone to the ribbons. I also stroke tone on the horseshoe, following the direction of the form. Using the tip of the same stump, I touch in shadows on all the objects. I switch to a smaller stump to shade the flower design. Applying light pressure and curving strokes, I add a touch of tone to the postcard. And then I use a very thin stump to carefully tone the dollar bill.

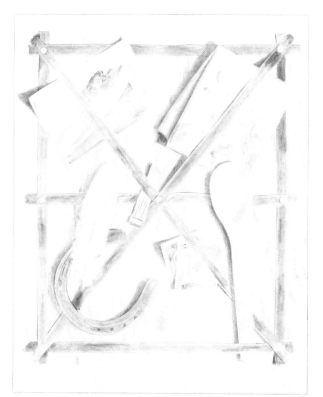

Step Four I apply the ribbon's cast shadows with a sharp 2B, paying careful attention to the thin shadows along the edges and how they curve as the ribbon lifts from the board. I deepen the cast shadows around the rest of the objects before adding detail to the fabric and horseshoe, texture to the feather, and tone to the matches. I switch to a sharp 2H to add the design to the currency. With a medium stump, I tone the spoon, postcard, and feather. I switch to a large stump for the grain pattern.

4

5

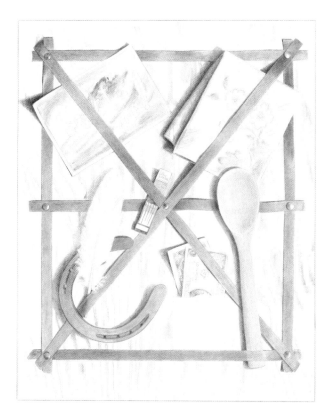

Step Five Using the stump's tip, I tone the tacks. Then with a 4B, I further define the tacks, deepen the ribbon and horseshoe, and refine the card and fabric shadows. I deepen the tone in the waves with the sides of both a 2B and a 4B. Then with a kneaded eraser, I lift out highlights on the ribbon and tacks, also "drawing" the white wave. I switch to the 2B for the fabric and spoon. For the matches, I use the thin stump on the tips, the 2B on the cover, and the 4B on the cast shadow. I switch to an HB to add feather texture and refine the detail of the dollar.

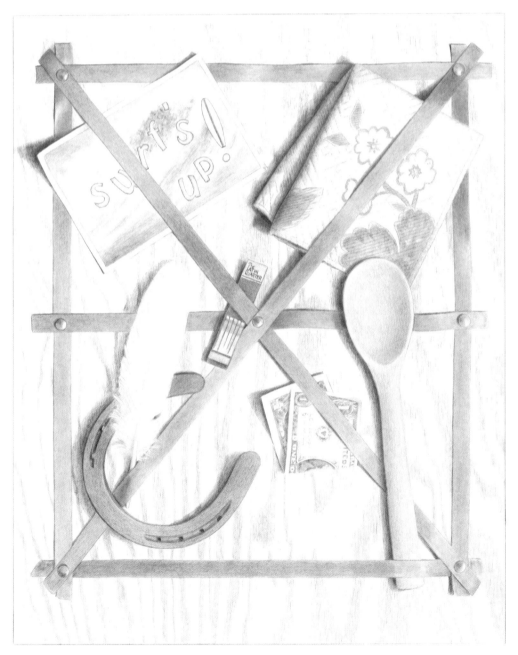

Step Six I use a sharpened 4B to refine the ribbon's shadows and the horseshoe, switching to a 2B for the postcard print and the spoon tone. To create fabric texture, I work with the 2B's tip and 4B's side. Next, I pick up the HB, using the side for the fabric quilting and the tip for the feather shading and dollar detail. For the matches, I use a sharp 4B for tone and a sharp HB for detail. I add wood grain texture using a 2B and long strokes; then, with the sharp tip, I make short lines, varying spacing for a natural look.

Understanding the Subject's Context

Creating a realistic drawing is about more than proportion and perspective. You could have a perfectly rendered polar bear with exact anatomy and detail—but if you place it on a beach, the viewer isn't going to find a lot of believability in your portrait! That's why it's important to understand the context of your subject, whether it's an object, a person, or an animal, like the Crab-Eating Macque that's the focus of this lesson.

Doing Your Homework Zoos are a great place to observe animals, because the keepers typically create environments that reflect natural habitats. I took a lot of photos of the rocks and water surrounding this monkey at the zoo. But I also researched the monkey, finding out about its native habitat in Southeast Asia and confirming the relevance of the water and rocks. I also learned that it's a very social animal, so I decided to include a second monkey.

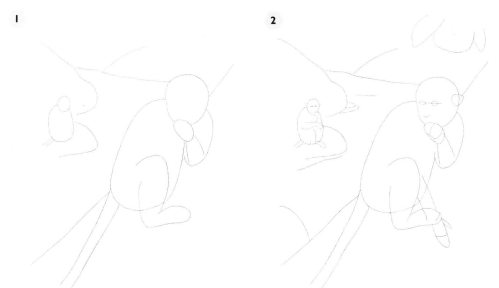

Step One I start the main monkey: two oval shapes for the head and body, a simple outline of the arms and legs—with an oval to represent the hand—and the tail. I also indicate the tree, background rocks, and water with a few simple lines. For the background monkey, I draw two ovals in proportion to both each other and the main monkey.

Step Two Now, I add a little more detail to the outline. I make a line on each monkey to establish the position and angle of the eyes, which I draw in as small almond shapes. I add the ears and indicate the position of the nose. I also block in the other arm of the main monkey. Then, I add curved lines to indicate where the hands and feet bend.

40

3

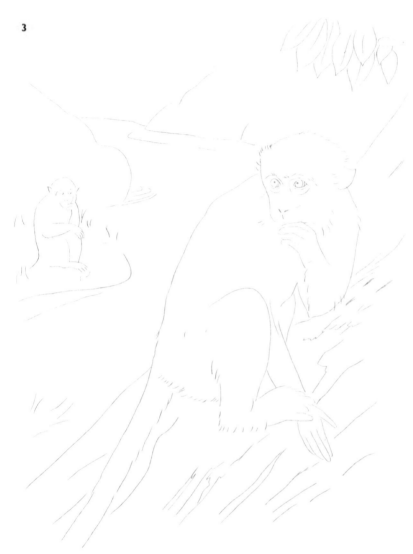

Step Three I lay a heavyweight tracing paper over my initial sketch and begin to redraw the monkeys, refining the shapes of the bodies as I go. I create a more natural outline by interrupting the figures with a few short lines of hair texture. Then I work in a little detailing, focusing first on the eyes, nose, and ears, and then on the fingers and toes. With long strokes, I indicate a little texture on the tree, and I also add leaves, lines for the water, and rock outlines in the background.

Depicting Hair Growth

In some photos, it can be a challenge to see the direction or the pattern of hair growth well enough to depict it in your drawing. But not to worry, you can look for other photos of the same species as a reference. Using that resource, you can create a diagram of the hair growth to work from.

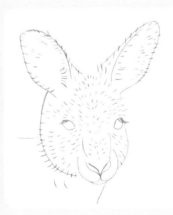

In this example, I drew the outline of the head before carefully studying the pattern of the hair, which I depicted with short lines showing the direction of growth for the individual hairs.

41

Sketching Feet

Details matter when you're depicting animals. Unfortunately, photos don't always do justice to smaller features, like hands and feet. When I'm visiting the zoo, I always take many detail shots of the animals so I'll have reference material on hand when I need it.

Animals with hooves, demonstrated by this giraffe, often will use their feet to protect themselves.

Animals don't all have the same number of toes— this llama has two, plus a large pad for gripping purposes.

The camel likewise has toes instead of a hoof, with a very large pad to help the animal walk across sand.

4

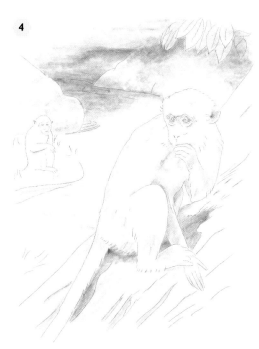

Step Four Before continuing, I transfer my drawing to Bristol paper. Next, I lay in a base tone using a large stump and stroking in the direction of the hair growth on the monkeys. With the stump's tip, I tone the eyes and ears. I switch to the stump's side for the tree. Then, I make irregular strokes, both circular and straight, to tone the rocks. Finally, I use horizontal strokes for the water, which gets a deeper tone along with the rocks and tree.

5

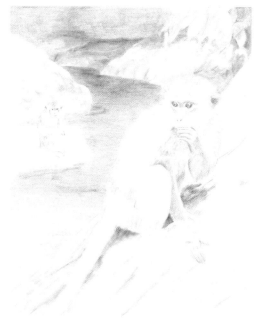

Step Five For tone on the monkeys, I use the side of a 2B, making short strokes and following the direction of growth where applicable. To define the facial features, I use the point of the pencil. Then I add darker texture to the tree with back and forth strokes that are at the same angle as the tree; irregular lines indicate the bark. Next I use the side of a 4B to shade the water with horizontal strokes. And I add texture and tone to the rocks by applying irregular strokes with the side of a 4B.

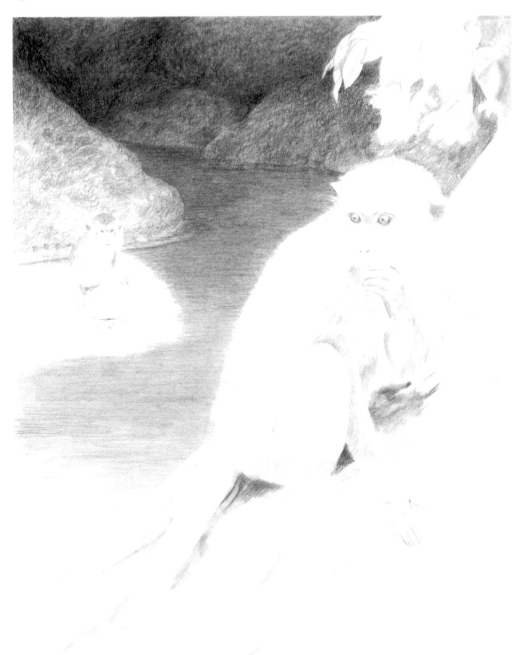

Step Six Because the background is so dark, I'm going to concentrate on bringing it closer to its final value rather than developing the whole drawing at once. Applying heavy pressure and making circular strokes with the side of an 8B, I build up the tone of the rocks. For the crevices, I use heavier pressure to create a very dark value. I use the 6B and horizontal strokes to build up the water; where the water meets the rocks, I further deepen the tone. And for the rock behind the monkey, I lift out additional texture.

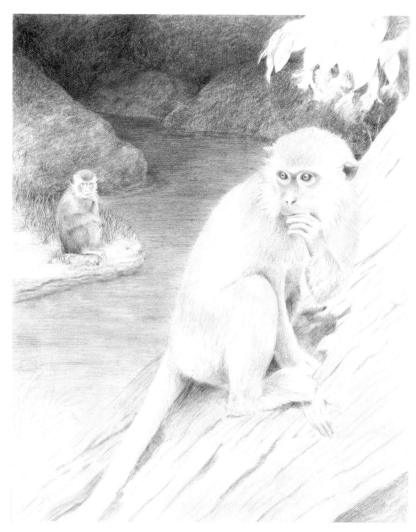

Step Seven Now I build up the hair texture, switching between the side and point of the 2B while creating short strokes that follow the direction of growth. I use a kneaded eraser to pick out white hairs. Next, I shade the faces using delicate strokes applied with the side of the 2B. I add detail to the eyes using both the HB and 2B pencils. Then I further refine the ears, hands, and feet. With the side of the 4B, I add texture to the tree, stroking in the direction of the bark. I also use the point of the 2B to add grass to the small island.

7

Understanding Habitats

Understanding how animals relate to their natural habitats is important if you wish to depict them realistically. I find it helpful to create small studies before making a more detailed drawing. This practice is especially helpful if you'll be combining references for your final piece.

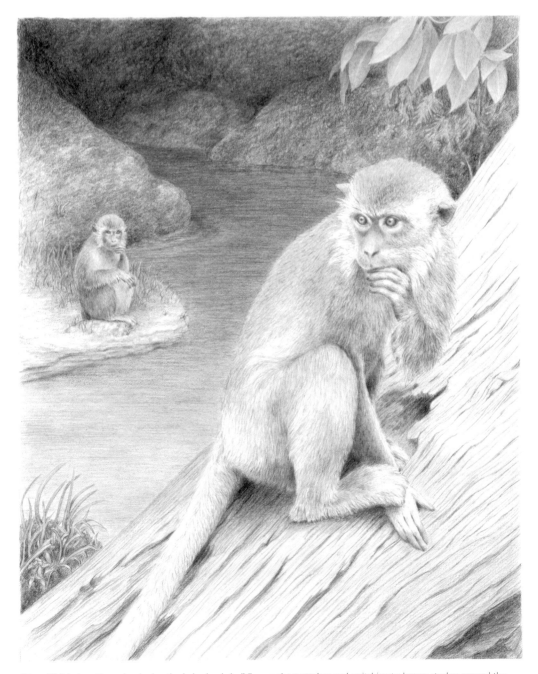

Step Eight I continue developing the hair, slowly building up short strokes and switching to longer strokes around the face and arms. To define the facial features and shading, I use a sharp 2B. For the tree's texture, I apply long strokes with the point of the 4B, adding dark lines where the bark is cracked. I use a 6B to darken the monkey's cast shadow. Then for tone on the island, water and hanging leaves, I use the side of the 2B. And finally, for the small patch of grass in the foreground, I use both a sharp 2B and 6B.

Applying Linear Perspective

Many beginning artists shy away from architectural subjects because they worry about depicting the buildings accurately with all their angles and dimension. But once you understand a few simple rules of linear perspective, it's easy to approach subjects like this historic piazza in the historic Italian town of Assissi. It's just a matter of breaking the subject down into simple shapes and understanding how those individual shapes relate to the horizon and vanishing point in the distance.

One-Point Perspective

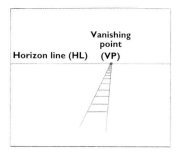

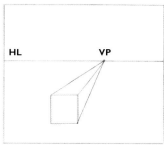

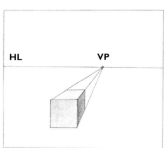

Two-Point Perspective

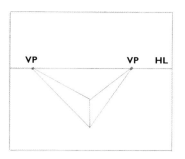

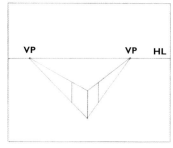

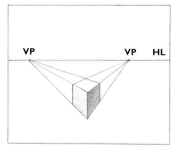

When the viewer faces the front plane of an object, the perspective is one-point perspective. There is one vanishing point on the horizon line, where all lines converge. For example, if you were viewing a set of railroad tracks, the rails would converge in the distance at the vanishing point. To draw an object in one-point perspective, first I draw the horizon line and vanishing point. Then, I draw the front of the object, followed by a line from each corner of the object to the vanishing point. Finally I draw lines for depth.

When an object is not viewed head on, two-point perspective is employed. Here, two vanishing points are located on the horizon line. First I draw the horizon line with two vanishing points. Then I draw a vertical to represent the location and height of the item. After creating converging lines that travel from the top and bottom of the object to each vanishing point, I establish the depth with vertical lines. Finally, I draw lines from each corner to the opposite vanishing point.

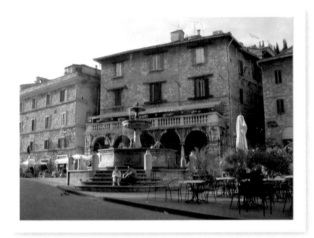

Removing Perspective Distortion

I try to stand as far back as possible when photographing a building, so that the photo's perspective isn't distorted in my image. But inevitably, you'll need to make some adjustments and corrections if you're going to be working from a photo. Rather than drawing these buildings exactly as I see them, I'll use a right-angle tool and a ruler to establish a more accurate portrayal than my camera captured.

I

Step One I start my sketch with the main building, thinking of it as a large box. I use a right angle tool and a ruler to establish the lines in perspective. Then I do the same for the building on the left. With the buildings in place, I draw the windows. Next I block in the shape of the terrace, using verticals to indicate supporting arches and columns. To draw the fountain, I sketch simple lines and ovals to suggest the basic shape. And I represent the plants on the right with large organic shapes.

2

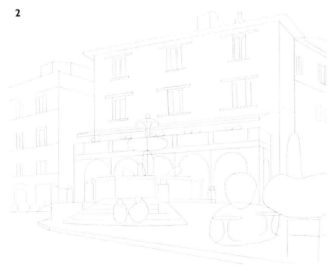

Step Two Now I add a little detail and refine some of the shapes. I add the roof to the building, along with windows detail with the help of my ruler. Then I create the arches and columns, along with the awning for the terrace. I represent the plants on the terrace and down the street with simple ovals. I create additional detail on the fountain, checking all verticals with my right angle tool. I also add stairs to the fountain, and I block in the couple sitting on the steps. Finally I draw the two tables at the right of the composition.

3

Step Three This is a more complex subject, but it becomes approachable if you take it in stages. We'll use this base sketch as a guide for the more detailed drawing. On a sheet of tracing vellum, I copy over the base structures, adding more detail to the roof, windows, and terrace. I refine the drawing of the plants and draw in the lanterns. I make some indications of stonework, and I roughly draw the two figures that are seated at the fountain. I also draw the umbrella, chairs, and plants before transferring to Bristol board.

4

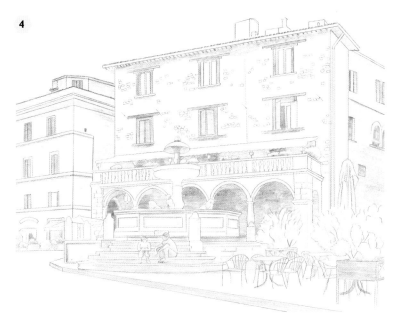

Step Four Now, using the side of a 4B, I tone the sides of the buildings, stroking along the angle of the perspective. With the pencil tip, I dot the roof to indicate tiles. I stroke horizontally to shade under the roofline, terrace awning, and arches. With the side of a 2B, I shade the windows and shutters. I also tone the fountain, following the form. I shade the distant doorway and plants, plus add texture to the plants using a 2B. I lightly shade the umbrella. Then I tone the planter and street curb with heavier pressure.

5

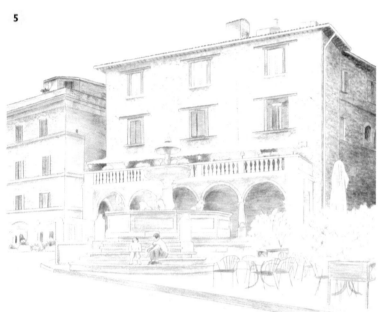

Step Five To develop building texture, I make short, wide strokes with the 4B, varying pressure. I apply heavier pressure on the sides. I also deepen tone under the roof and add window shading. Switching to a sharp HB, I define edges. With the HB's side, I shade the top windows, tone the supports, and deepen under the arches. Then I make curved strokes with the side of the 2B to shade the upper fountain. For the base and steps, I use long horizontal strokes. I apply dark tone to the chairs and use the 2B for plant texture. I also tone the ground with the side of a 4B.

6

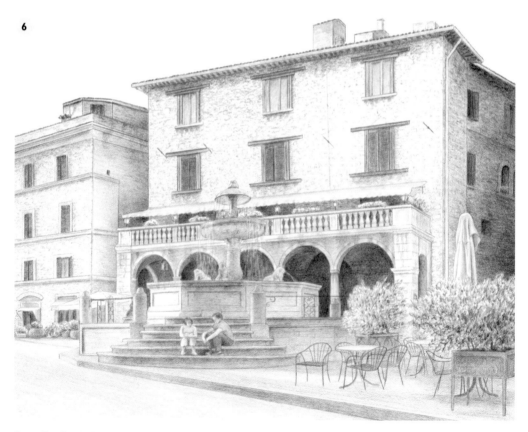

Step Six For the buildings, arches, and columns, I add the darkest shadows with a 6B, refining the edges with a sharp HB. Under the arches, I lift out light areas. I shade the balusters, tone the awning, add plant texture, and shade the lights on the terrace. Next I shade the upper fountain using the 4B's side. To create water, I lift out tone. For the base and steps, I use both the 2B and 4B, refining edges with an HB. I shade the planters, also deepening shadows under doors and on the umbrella. I tone the ground. And then I finish with a sharp 2B, deepening the planter bases and refining edges.

49

Achieving Depth

A gorgeous spring day when the sun is out and the flowers are in bloom is practically an invitation to sketch a landscape! But when I seek subject matter, I'm looking for more than a pretty spot—I also search for a scene with features that will help me portray depth. A distinctive foreground, middle ground, and background will help me portray *atmospheric perspective*—the tendency of objects to appear less detailed as they recede from the viewer. And overlapping elements are another key to creating a sense of three-dimensional depth in a two-dimensional drawing. Look for both in your composition.

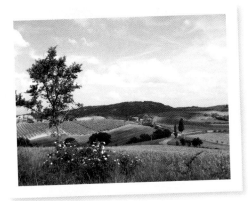

Finding Inspiration It's hard to resist the Tuscan countryside, but you can find beautiful landscapes in your backyard, too. Keep an eye out for overlapping elements, such as a tree in the foreground or a mountainside in the distance. Then take many photos. Don't worry if your landscape isn't naturally "picture perfect"—just change it in your sketch.

Eliminating Distractions Detailed landscape scenes can be very distracting. I recommend simplifying the scene before you start by zeroing in on the main shapes and values of the design. A quick value study that focuses on four to five key value "notes" will help you think "big picture."

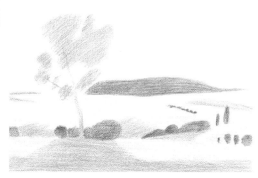

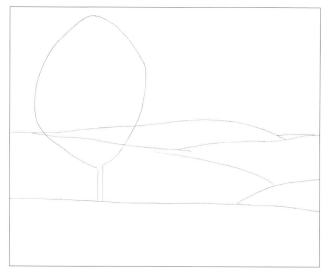

1

Step One Earlier I mentioned improving the composition at the sketch stage: I do so by moving the foreground tree and cropping into my photo. I'm still thinking big picture here, blocking in a big oval for the tree and horizontal lines for foreground grass. The main hills I depict with curving lines, paying attention to overall shape and proportion.

Step Two Taking small steps toward adding detail to the drawing makes it very approachable. Next I add the main branches of the tree, placing them inside the larger oval of the tree. I use smaller ovals for large masses of leaves. At this time, I also draw the road, again using ovals to represent bushes, trees, and even a house in the distance.

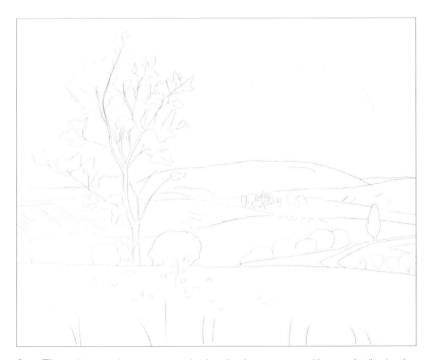

Step Three I tape tracing paper to my sketch and redraw my scene with more detail, using the sketch as a guide. I establish the trunk and main branches of the foreground tree. I also map in the shapes of the various tree masses and bushes, as well as a cloud. Small circles indicate flowers. I add crop lines to the hills, and a few grass blades to establish the direction of growth.

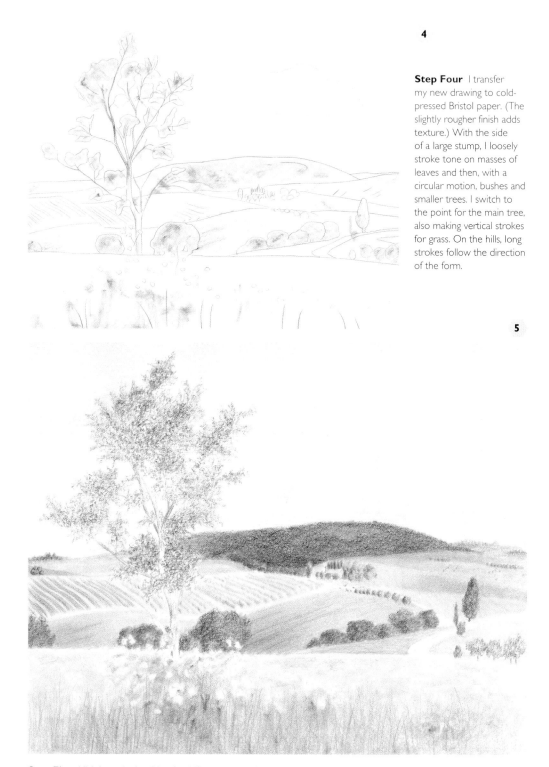

Step Four I transfer my new drawing to cold-pressed Bristol paper. (The slightly rougher finish adds texture.) With the side of a large stump, I loosely stroke tone on masses of leaves and then, with a circular motion, bushes and smaller trees. I switch to the point for the main tree, also making vertical strokes for grass. On the hills, long strokes follow the direction of the form.

Step Five I lightly apply the side of an HB to the sky, lifting out clouds with a kneaded eraser. I use the side of an 8B for leaves, pressing harder in shadows. Switching between the 8B and a stump, I work the bushes, trees, and distant hill with small circular strokes. Then with a 2B, I apply long strokes to the hills and left-side crops, and short, curved strokes to distant crops on the right. In the foreground, I alternate between a stump and the side of a 4B, working around flowers. With the 2B and 4B, I add grass and shadows.

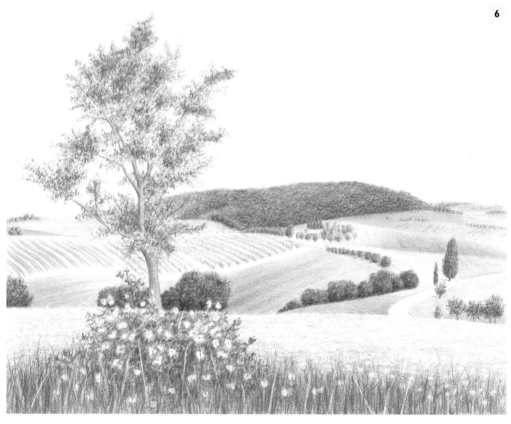

Step Six Next I build dark tones on the hill, bushes, and tree with the 8B's side, refining the hill's shading and tree trunk with the 2B's point. I build leaf texture with the 6B's side. I revisit the crop areas. Then with a 2H, I lightly shade clouds. I build foliage beneath the tree using scribble strokes and a 6B, creating stems with the point. I lift out tone for the flowers, stippling in the centers. For grass, I alternate between long strokes with a sharp 4B and an eraser. I add texture in the foreground with the 6B's side, also lifting out dabs of light. When I finish, there's a distinct contrast between detail in the foreground and background that gives the drawing a clear sense of depth.

Emphasizing Atmospheric Perspective

It's important to remember that as objects recede into the distance, detail and contrast are both lost as a consequence of atmospheric perspective. If your photo doesn't clearly capture this effect, feel free to emphasize it in your drawing to distinguish foreground from background. Doing so will prevent your drawing from appearing flat.

The same cactus can appear very different depending on where it's located on the picture plane. The atmosphere blurs the detail and even lightens the tone when the object is placed farther in the distance.

Selecting the Best Format

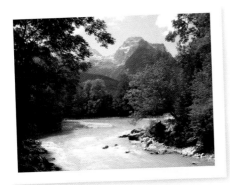

Collecting Travel References While I was traveling through the Alps, I was surrounded by spectacular scenery; I took hundreds of digital photos, but with other things on my mind at the time, I didn't concern myself too much about framing the perfect composition at the photography stage. When I found a scene that was particularly nice, like this river, I photographed it from many different angles. When I finally decided to draw the subject—two years later!— I found I had plenty of reference to work from.

Once you start drawing, it's impossible not to look at the world through an artist's eyes! But you won't always have the opportunity to stop and take the time to frame a perfect composition; sometimes it's best to focus on collecting as much material as you can in the moment so you can refine it at a later time. You've seen me combine references and move objects to improve a composition; now here's another trick: Always check to see if you can improve a composition by cropping the photo—not only zooming in on the subject, but finding the best format—such as vertical, horizontal, or square—to frame the subject, one that will best bring out its natural beauty.

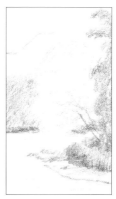

Vertical The vertical approach is a great way to experiment with a subject, seeing it in a different way. It works well for tall objects, like a tree or a person. Applied here, it really pulls in the focus on the mountain—but the value composition is imbalanced.

Horizontal Wide formats are normally a great choice for landscapes. From this simplified thumbnail, though, you can see the way the dark masses on both sides are competing for attention, crowding out the mountains in the background.

Square We usually think in terms of vertical or horizontal layouts, but nothing's stopping you from ovals, circles, panoramic horizontals, vignettes, or even squares! With this scene, the square format was the perfect complement to create a strong composition.

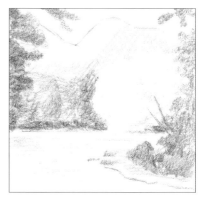

Step One As usual, I start by blocking in the largest masses with basic shapes, loosely defining the large tree in the foreground, the trunks, the shape of the river, and the background mountains. Pay careful attention to the shape of the river, noting where it intersects the tree. The focus is on placement and proportion at this stage.

I

Step Two I add a bit more rough detail now, representing the main leaf masses with ovals, making a curving shape for the tree and leaves on the right side of the scene, and roughing in angular lines and ovals for the rocks at the base of the tree and in the river. More ovals represent background trees and leaves, and I further delineate the mountains.

2

Step Three Placing tracing vellum over the sketch, I re-sketch the scene, beginning with the river, where I add detail to the riverbank and rocks. I break up the rock masses under the tree, and then I better define both the foreground tree and trees in the background, using irregular lines for the leaf masses and mapping out major branches. I further refine the shapes of the mountains, and then transfer my drawing to cold-pressed Bristol board.

3

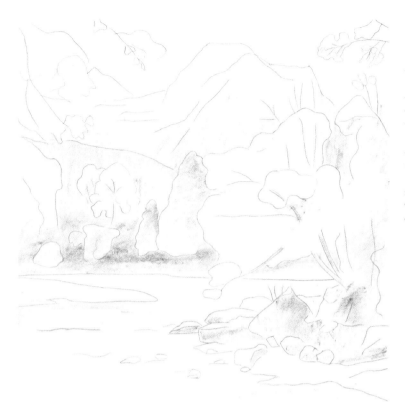

Step Four I wash in the base tone with a large stump, starting with light vertical strokes on the mountain, and continuing with heavier, shorter vertical strokes on the forested hill. I loosely indicate masses of leaves on the branches and trees near the riverbank, and I apply light horizontal strokes to the water. I also wash over the major planes of the rocks.

4

5

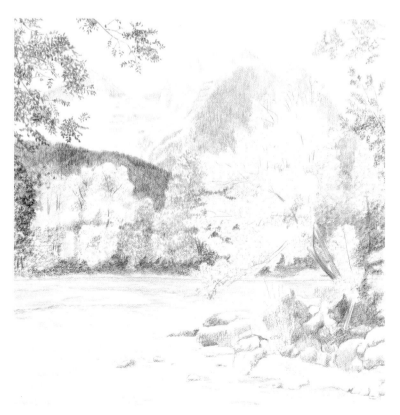

Step Five With the 6B's side, I apply short, vertical strokes to the mountains, applying more pressure for texture on the forested hill. For the hanging leaves, I add short strokes in various directions with the blunt 6B. Switching to a 2B, I make short, curved strokes and stipple the trees along the river edge, applying a lighter touch on the large tree in front. Slightly wavy strokes tone the river. I use the 4B for branches and the trunks. I apply the 6B to the rocks, using heavier pressure in shadow and the blunt point for edges.

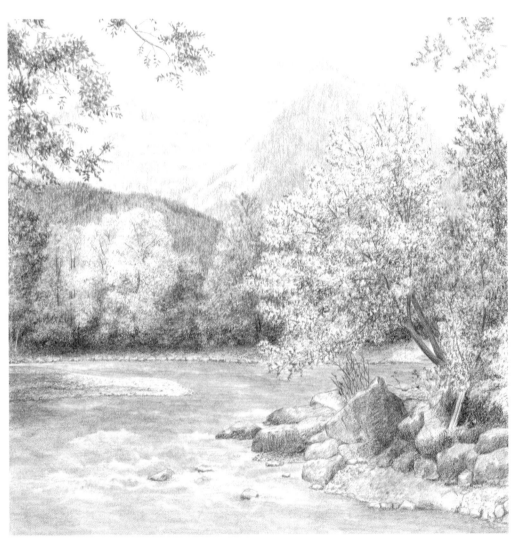

Step Six I return to the mountain and forested hill, building tone. I also return to the hanging tree branches with heavier, darker strokes. For the riverbank trees, I shade with both a 4B and a 6B. I make curved strokes with the 6B to tone the large tree, defining branches with the point. For the river, I alternate between the HB and 2B, stroking horizontally. I also lift out "white water" shapes. I use the 6B's blunt point to make lines on the rocks, following the direction of the planes, also adding details to rocks along the water's edge. To create texture on the sandbar, I use the 4B's side. Now you clearly can see why the square format was the best choice for this scene—the elements are nicely balanced!

Bringing It All Together

It's very rare that you'll ever focus on just one aspect of creating a drawing, whether it's lighting, composition, or combining elements. Now it's time to pull together everything we've covered so far to approach a simple portrait. You might be surprised at how much you've learned already over the course of just a few short projects!

Capturing Character The key to a good portrait is letting the natural personality shine. This kind grandfather rarely leaves the house without his favorite cap, and a portrait of him wouldn't be complete without it. Moreover, harsh shadows or a more stoic expression really wouldn't suit him, so I tried to capture a gentler expression with soft shadows to complement his character.

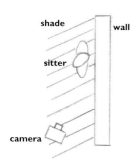

Outdoor Lighting I like to use natural light when taking photos for a portrait, but direct sun causes squinting eyes and harsh shadows, which can be very unflattering. One way to circumvent this is to photograph the subject outdoors in open shade, having an individual stand or sit near a wall that casts a shadow.

Indoor Lighting: It's also possible to take advantage of natural light indoors, as long as you have a large window present. Simply position the subject sitting or standing near the open window (but not directly in front of it, as this will cause backlight shadowing). This works with any indirect light, but I prefer north light myself.

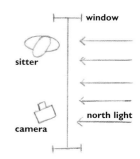

Step One Because we're working with a portrait and the placement of features is essential to make the individual recognizable, we're going to work with the grid method again, placing an acetate grid over the photo and printing out a paper grid for my sketch. I slowly transfer each corresponding square, being especially careful with the facial features. I draw only the most important lines, not details like the individual hairs of the mustache. When completely transferred, I tape tracing vellum over my grid drawing.

2

Step Two Now it's time to redraw my sketch with more detail. I outline the face again, refining lines such as the subtle curve of the cheek. I also revisit the features, again refining lines, and this time indicating the direction of the mustache hair. I also touch in some of the details of the stitching on his shirt before checking for accuracy, and then transferring my refined sketch to a piece of plate-finish Bristol paper.

Character Accessories

Just as my subject for this drawing is never without his favorite cap—which happens to speak worlds about his personality to the viewer, simply by its presence—accessories and props can be used to accentuate personality or establish a particular feel in a portrait.

A scarf provides style or flair

Hair clips adds a feminine feel

Prints express favorites (such as animals)

Jewelry accents individuality

Ties imbue a formal or professional air

Adjusting for Children's Features

Indirect, natural light is all the more important when photographing children. It produces lighters shadows with softer edges, and also a more gradual transition of values between areas of light and shadow. Approach gradual shading like this in a slightly different way.

Step 1 I sketch the initial outline of the child's nose with an HB pencil before adding some curving strokes that follow the forms of the nostrils and ball of the nose. I touch in just a few strokes for the cast shadow, also applying dark tone inside the nostrils.

Step 2 Next I switch to a 2B, lightly adding more curving strokes to begin modeling the nose's form. For a very fine cross-hatching, I also lightly stroke in a different direction, but still following the form. At this stage, I also deepen the cast shadow.

Step 3 Still following the form, I model the shading with gradual tonal changes before picking out the highlight with an eraser. I deepen the cast shadow, keeping the edges soft. I also deepen the nostrils with a sharp 2B before I finish shading with an HB.

3

Step Three I study the face's planes before picking up a 2B to start lightly shading the side of the cheek with long, vertical strokes that curve around to the jaw. I stroke tone over the whole ear, thinking of it as a solid plane. Then I apply straight strokes to the nose's side plane, curving around the ball of the nose. I add darker tone in the nostril, lightly shade under the lips, and also tone the irises with radial strokes. I tone the top of the cap and the shadow underneath, approaching the brim with long horizontal, strokes.

4

Step Four Still using the 2B, I slowly build up the shading. I revisit the side plane of the nose, changing the direction of the strokes but still following the form. I lightly shade under and around the eyes, as well as around the cheeks. With shorter strokes, I tone the upper lip in the "down" plane, plus the corners of the lips. I alternate between radial and circular strokes on the iris, lifting out highlights before lightly toning the "whites" of the eyes. I deepen tone on the side of the cheeks and ear, also shading the side of the neck and around the collar. Then I return to the cap, stroking underneath in the direction of the eyebrow hairs and also deepening the brim and top before lightly toning the "white" area.

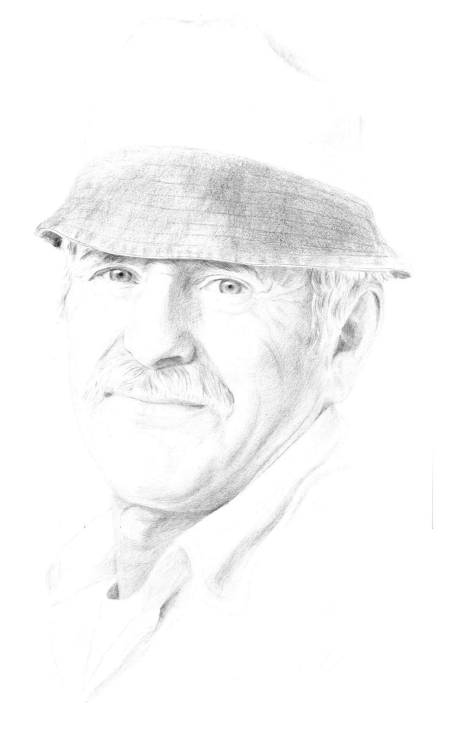

Step Five Still gradually building up the tone with the 2B, I now turn my attention to the light values, keeping my strokes soft and delicate. Around the cheeks, chin, mouth and eye, I curve the strokes around the forms. I also deepen the hair and mustache following the direction of growth, switching to a sharp 4B for the darkest areas. I apply detail to the ears and nose with the 2B, again switching to the 4B for the deepest shadows. And then I further shade the shirt before filling the cap's darkest areas with a 6B.

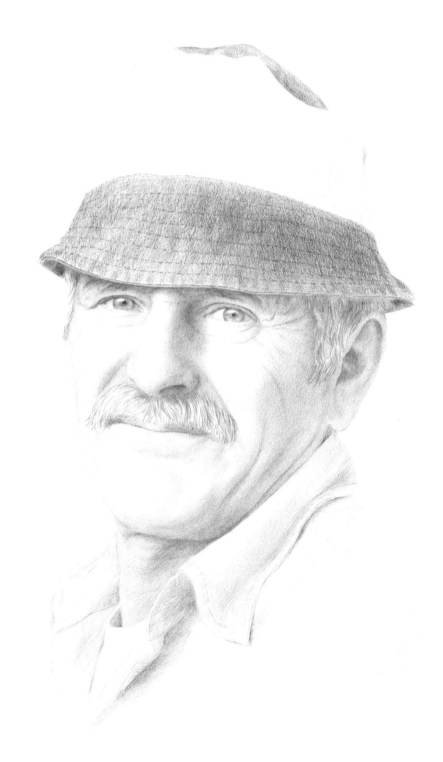

6

Step Six To deepen shadow accents around the eye, ear, and nostrils and under the jaw, I use the point of a 4B. I turn to the point of a 2B and short strokes to refine shading and smooth out tone. For lighter areas, I apply the same method with an HB. For detail in the mustache and hair, as well as on the shirt's stitches, I switch to the 2B, using the side for light shading on the shoulder. I return to the 6B for the dark areas of the cap, applying the light shading with the 2B and using the 4B's point to accentuate the stitching. And after cleaning up stray marks with an eraser, my portrait is ready to frame!

A Note of Encouragement

Although my goal with this book was to help artists work with technology—such as the digital camera and the computer—you may have noticed that all the basic principles of art still apply, even with the help of these tools!

The camera can help us gather visual information in a twenty-first century way, and also increase our efficiency as artists, but the artistic vision still resonates from within you, not the machine.

I have often thought about what the great masters would have done with all the high-tech tools artists have available today. But spending time studying their works, it quickly becomes apparent that they used the tools available to them in their era to their best advantage, as well. And that didn't take away from the art they produced. To the contrary, the tools gave them a better means of expressing their vision, passion, and perseverance for excellence, those inner qualities that gave rise to their greatness.

I am convinced these great artists also would have taken advantage of our technological world if they lived in the modern age, but the spirit of their art would still persevere. In that vein, I hope that you use the information in this book and the technology available today to serve your art, and to help you express your passions.